I have asked that this book be dedicated to all artists who have faithfully honed their craft in reverence for the beauty and value of Creation. This commitment of their work to the inherent mystery and beauty of life has been the hallmark of the great ages of art—and will be again.

<div align="right">

FREDERICK HART

</div>

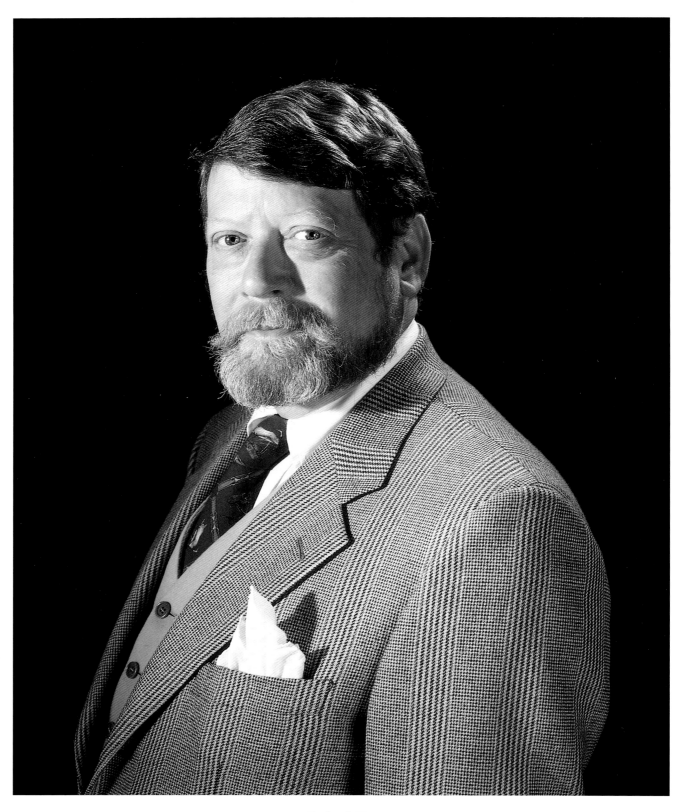

*Frederick Hart*

# FREDERICK HART
## SCULPTOR

INTRODUCTION BY

# J. Carter Brown

A COMMENTARY BY

# Tom Wolfe

ESSAYS BY

Homan Potterton

James M. Goode

Frederick Downs Jr.

Frederick Turner

Donald Martin Reynolds

James F. Cooper

Robert Chase

DESIGNED AND PRODUCED BY

Marshall Lee

HUDSON HILLS PRESS • New York

Printed in Italy by Sfera , Milan
ISBN 1-55595-120-1
Library of Congress Catalogue Card Number 94-79869
First Edition: Fifth Printing
Published in the United States by Hudson Hills Press, Inc., 1133 Broadway, Suite 1301
New York, NY 10010-8001.
Editor and publisher: Paul Anbinder
Distributed in the United States, its territories and possessions and Canada.
by National Book Network.
Distributed in the United Kingdom, Eire, and Europe by Windsor Books International.

## ACKNOWLEDGMENTS

Many friends, colleagues, and organizations contributed their time and expertise to this book. Sincerest thanks are owed to: the authors for their insightful understanding of the subject; Robert Chase, whose enthusiasm and commitment to Frederick Hart and his work has sustained the project since its inception; and Madeline Kisting, who capably managed the project and provided guidance and counsel. The book has been significantly enhanced by the editorial judgment of Mary Yakush and by the design, typography, and production supervision of Marshall Lee. In addition, Pamela Hoyle, with the assistance of Lori Schwartz, expertly compiled the Catalogue Raisonné and Alexander V. G. Gaudieri collaborated in the original concept of the book. We wish to thank also the staff of the Washington National Cathedral who graciously permitted access to the archives and responded to queries: Joseph Alonzo, Jennifer Faircloth, Richard T. Feller, Richard Hewlett, Vincent Palumbo, Christine Theberge, Dr. Charles Tidball, Barbara Ullman, and Eileen Yago, and the following, whose cooperation has contributed to the book's success: Philip Allen, Craig Broffman, Cavalier Foundry, Geoffrey Charlton-Perrin, Moya Chase, Robert Chase Jr., Margaret Clark of the Cosmos Club, Colbar Art Inc., Ovidiu Colea, Rodney Cook, Jim Durish, David Farmer, Fine Art Ltd., Elliot Gantz, Tom Gee, Lindy Hart, Ann Hoy, Lee Kimche, Susan Lawson-Bell of National Air and Space Museum, Meisner Foundry, Barbara Newington, Mario Noto, Pat Phibbs, Lori Rehfelt, Rami Ron, Sheryl Rudat, Diane Schroeder, Lizabeth Sipes, Gurdon Tarbox, Sally Webster, Alexandra York, and Emily Zerweck. Above all, we acknowledge the unfailing support of Frederick Hart, whose talent and inspiration made this book possible.

## PHOTOGRAPH CREDITS

The photographers listed below supplied the photographs on the pages whose numbers follow their names. (Photos which appear in the Catalogue Raisonné are indicated by the page number followed by the catalogue number, e.g., 124 (CH 10), etc.)

Darrell Acree: Jacket, 22 top, bottom, 23 both, 27 both, 28 top, 29 both, 34, 35, 37 both, 40 top, 48, 50, 51 bot., 52, 54, 74 top left and right, 90, 96, 124 (CH 10-15); Gabriel Benzur: 113; Morton Broffman: 21 top, middle, 26 top, 32; Raymond Brown: 26 bot.; Sisse Brimberg: 24/25 © National Geographic Society; Byron Chambers: 20 middle, 123 (CH 8), 124 (CH 16,17), 125 (CH 18-25,), 126 (CH 30a,b,c,d); Foster Corbin 112 both; Libby Cullen: 18, 28 bot.; Robert Doubeck: 51 top; Edward Fojtik: 77 both; James Hedrich: 88 top, 89, 98 bot. left and right,100; Richard Hertzberg: 87,101; Carol Highsmith: 2, 20 bot., 30, 31 top, 33 all, 36 bot. left and right, 38 both, 39 both, 47, 49, 88 bot, 97 both, 110 bot., 114, 123 (CH 2,4), 126 (CH 33), 131 (CH 77), 132 (CH 97); David Hofeling: 73, 74 bot., 75 both, 83, 86, 91, 92, 93,102, 103, 104 both, 105, 106, 107 both, 108, 109, 111, 115, 116 left and top, 117, 118, 119, 128 (CH 54), 129 (CH 56-58), 130 (CH 61-64, 70), 132 (CH 94-96); Michael Korol: 85, 94 top, 95, 99, 116 bot.; Robert Llewellyn: 36 right top; Melville Mclean 127 (CH 37-40); Dane Penland/Smithsonian Institution: 55 top; Barrett Randell: 40 bot.; Richard Shay: 94 bot., 98 top; Stewart Brothers: 123 (CH 5), 123 (CH 9), 126 (CH 32); James H. Wallace, Jr./Smithsonian Institution: 110 bot.

We are grateful to the following, who have provided the photographs indicated:
Alinari/Art Resource, NY : 31 bot. left and right, Fine Art Ltd.: 78, 130 (CH 75,78), 131 (CH 85,91); Col. and Mrs. E.L. Lucas: 20 top; The Metropolitan Museum of Art, NY: 65 top; National Air and Space Museum: 128; National Museum of American Art/Art Resource, NY 65 bot.; The Philadelphia Museum of Art: 64., The Smithsonian Institution: 55 bot.,56.

# Contents

# Illustrations

NOTE

The data about each Hart work illustrated can be found
in the Catalogue Raisonné. The number of its Catalogue
entry is printed under the illustration's caption.

7

# *Introduction*

## J. CARTER BROWN

One of the functions of art is to challenge. Frederick Hart's sculpture is among the most challenging art I know.

That we live in a pluralistic society is painfully obvious. Much as we might yearn for a simpler yesteryear, the competing diversities of our time are the source of great potential strengths, as well as all kinds of paradoxes. Simplistic generalizations—such as the often-repeated description of nineteenth-century art as caught in tension between the academic and the subversive—cannot begin to describe the current complexities of our art.

In the late twentieth century, innovation has become such a shibboleth that the concept of the avant-garde has lost its meaning, except perhaps to the extent that the roles of one hundred years ago may now be reversed. The preoccupation with innovation poses a threat because it exposes art to the heavy winds of politicization and ideology. What the great English critic I. A. Richards excoriated as the "stock response" lies at the heart of what art should not elicit. Knee-jerk type casting, name-calling, and pigeonholing from any political extreme only damage the ability of art to function, infringing on the intellectual and aesthetic freedom so intrinsic to the role that art can and should play in our lives.

Frederick Hart's work and life have touched mine at a number of significant points. As each person's experience of art is highly personal, a brief delineation of each of these encounters might help illuminate how the challenge of his art has affected one observer.

The idea of a National Cathedral has held a special fascination for me ever since I came to Washington in the late 1940s. Having grown up in what was arguably the first major modernist residence on the eastern seaboard, I was intrigued by the notion of completing a Gothic cathedral in our own time. This was of particular personal interest because my father, as a young man, had commissioned a Gothic chapel for St. George's School from a nemesis of modernism, Ralph Adams Cram. The two collaborated closely over a period of many years, beginning in 1920, on the iconography and design. My father then selected the gifted young Boston sculptor Joseph Coletti to carry out an extensive program that successfully married the arts of architecture and sculpture. Yet this was the same father who supported the revolutionary Harvard Society for Contemporary Art in the 1920s, and who commissioned Richard Neutra to design a highly innovative modernist residence in 1936.

*The New York Times'* talented architecture critic, Herbert Muschamp, has written of the degree to which Cram, in his decades-long involvement with the still-unfinished Cathedral of St. John the Divine in New York, paralleled in many ways the spiritual quality of the exponents of Bauhaus

J. Carter Brown is the Director Emeritus of the National Gallery of Art, Washington D.C.

modernism, and its elevation of craft and quality of execution to an almost religious intensity. It is interesting to note that Alfred Barr, the great founding director of the Museum of Modern Art in New York, which followed closely on the heels of the Harvard Society for Contemporary Art, had devoted himself as a student at Princeton University to studying medieval art under Charles Rufus Morey. The legendary Meyer Schapiro, in the course of a long and distinguished teaching career at Columbia University, likewise straddled an enthusiasm for medieval sculpture and the expressive distortions of the twentieth century.

When, as the youngish director of the National Gallery of Art in the early 1970s, I heard that an even younger and to me totally unknown sculptor had won the competition to conceive and execute the sculptural program for the facade of Washington National Cathedral, I was highly curious as to how this challenge would be met in the aesthetic climate of our time. ( The process by which Frederick Hart first suggested and then won the competition is discussed later in this book.) My own response to the result was one akin to awe.

The intellectual voltage of the iconography of the facade is startling, reinterpreting as it does the creation myth after Pierre Teilhard de Chardin as one of continual becoming, counterposing the two patron saints of the cathedral—Peter the fisherman and fisher of men on the pillar on the "day" side, balanced by Paul, blinded by revelation, expressing the inner life of the "night" side—on either side of the nascent Adam under the central *Ex Nihilo* tympanum. Combined with its virtuosity of execution, the iconography of the cathedral commission added up, for me, to an artistic success. The style of the work does not try to recreate Gothic art; its Renaissance and romanticist predecessors are readily apparent; but its lyrical, humanistic, and ultimately spiritual effectiveness successfully transcend art-historical pigeonholing. Yes, spiritual; as Kenneth Clark has written, "Although we are all afraid, and rightly afraid, because there has been so much abuse of the word 'spiritual', in the end we cannot talk about art without using it".

Years later, in 1982, it was mandated at a famous meeting in the office of Senator John Warner that a figurative sculpture and flagpole would be added to the Vietnam Veterans Memorial, designed by Maya Ying Lin, on the national Mall. My fellow members of the Commission of Fine Arts were so apprehensive of this potential threat to the artistic integrity of Miss Lin's conception that their first reaction was to reject out of hand the ultimatum from then Secretary of the Interior James Watt that no work permit could be granted for work on the memorial (for which the handsome stone had already been quarried) unless the commission agreed in advance to accept the concept of the additions.

Fearing that we might lose Miss Lin's extraordinarily moving and successful design altogether, I was able to rally my fellow commissioners' support behind an answer to the secretary that agreed in principle, but left open the questions of the location and design of the additional elements. ( Theoretically, the commission, which by statute had approval authority along with the Department of the Interior and the National Capital Planning Commission, could have held out for elements a few inches high!)

It was obvious to me that one could not risk interfering with the quality of the competition-winning design; that plopping some figurative sculpture at the apex of the wall, reducing the latter to the role of a mere backdrop, could not be tolerated. Likewise, a flagpole, if placed on the upper lawn at the apex, might end up looking like a misplaced golf tee. The

day was saved by Frederick Hart. He understood instinctively that a figurative piece must be separated from the wall, and his sensitive solution, almost miraculously, both supplements and complements the experience.

No one to my knowledge has been able to elucidate the effectiveness of that group of three soldiers as articulately as the sculptor himself. Although his explication is quoted more fully later in this book, I cannot resist quoting him, in pointing out the aloneness and vulnerability of these three Americans who have suddenly come upon something they will never understand. The sculpture, Hart has said, "has a wholly unnerving and enigmatic, existential quality, which I think is very appropriate for the Vietnam War". It is particularly moving to think of them as reading their own names on that wall.

In 1985, two years after his three bronze figures were placed on the Mall, Frederick Hart became a presidentially appointed member of the Commission of Fine Arts, on which he served until 1989. Having been a member myself for more than two decades, I can report that only rarely in that time has another individual been as effective. Month after month, Frederick Hart's perceptiveness about architectural quality in a variety of styles, his viewpoint as a practicing artist, and his championing of the integration of sculpture into our built environment made a signal contribution to the work of the commission.

Since that time, I have had occasion to see his sculpture where he now creates it, in the midst of nature, in the beautiful countryside of northern Virginia. Although he has stated that innovation is not a priority for him, his pioneering use of Lucite, including a process that he has patented, is evidence that he is not an artist enslaved by the past. I find the Lucite work of particular interest in that it attacks in a new way the problems inherent in a highly finished realist style, addressing the constant challenge that specificity can descend into mere literalism. Hart's work is driven by his reach for the spiritual. The play of inner light in the Lucite work helps adduce some of the ambiguity and, therefore, the involvement of the viewer, to which Marshall McLuhan referred when he characterized radio as a "hotter" medium than television.

The challenges of working in a highly representational style are many. The risk of sentimentality, in addition to the threat of literalism, continuously threatens those who dare take this approach. We have seen so much vapid and saccharine nineteenth-century sculpture fall into that trap that it takes great concentration on the part of the modern viewer to refrain from easy, blanket condemnation on the basis of stylistic philosophy alone. There is, as well, the danger of virtuosity becoming an end itself. It is breathtaking to see an artist with the technical abilities and devotion to craft of Frederick Hart combine these gifts with an ability to go to the brink with them but somehow to keep dominant the inner, emotional, intellectual, and spiritual force of the work.

The more I study the history of art, the more convinced I become that manifestos, which may be essential to the sense of purpose, uniqueness, and motivation of the artist, have, in the end, little to do with whether a given work of art is or is not ultimately significant. The challenge to us as viewers is to see if we connect, one on one, with a work of art, screening out all the stridency and background noise that theory and polemics generate. As with all contemporary art, the perspective of time is the inescapable precondition of evaluation, yet my own feeling is that Frederick Hart's sculpture at once meets and transcends the numerous challenges of the late twentieth century.

11

# The Idealist
A COMMENTARY

# TOM WOLFE

Frederick Hart's story would fit right into Giorgio Vasari's marvelous *Lives of the Artists*, assuming the great Renaissance biographer might have had a taste for tales from the boiled-peanut Hoppin' John country of eastern South Carolina. Vasari doted on figures such as Giotto, the peasant boy who is discovered, miraculously, to have the divine gift of pouring living—or at least gloriously lifelike—human forms out of his fingertips and pulling them out of stone and clay. Giotto, as Vasari tells it, was out tending his father's sheep in a field one day in the year 1286 when the painter Cimabue happened to pass by on the way from Florence to a nearby village and saw him drawing a sheep on a slab of rock with a pointed stone. Bowled over by the boy's ability, Cimabue got the family's permission to take Giotto to Florence as his apprentice. With that twist of fortune the flowering of Renaissance painting and sculpture began, and the erstwhile peasant boy became the most famous artist of his time. On the level of unlikely career paths, at any rate, Frederick Hart's good fortune out-Lotto's Giotto's.

Hart was born in Atlanta in 1943, but his mother died when he was three, and he was packed off to her relatives in Conway, South Carolina, over near the coast in Horry County, where folks ate their peanuts boiled in salty water and their black-eyed peas cooked with tomatoes, Hoppin' John style. His high school career was distinguished by episodes of juvenile delinquency, his obsession with drawing pictures, particularly during classes in which he was supposed to be doing other things, and the fact that he failed the ninth grade—twice—but nevertheless managed to get into the University of South Carolina at the age of sixteen, by shooting the moon on the Scholastic Aptitude Test. He lasted six months. He was expelled when he became the lone white student to join 250 black students in a 1961 civil rights demonstration and spent four days in jail for breach of the peace.

Informed that the Ku Klux Klan was looking for him, he fled to Washington, D.C., and by and by got a job as an apprentice ornamentalist for the Gianetti Studio of Architectural Sculpture. Ornamentalists molded eggs, darts, acanthus leaves, and the like out of plaster for friezes and cornices. While at Gianetti he was discovered not by a Cimabue but by a stone

Tom Wolfe is the author of *The Right Stuff*, *The Bonfire of the Vanities*, and a book on contemporary American art, *The Painted Word*.

carver from Italy, Roger Morigi. As Morigi's apprentice, Hart learned to conceive of form in stone from the carver's perspective, from the inside out.

By day Morigi and Hart carved stone for Washington National Cathedral, an enormous structure in the Middle English Gothic style. By night Hart began sculpting on his own, and by the age of twenty-five he was pulling human forms out of clay and stone with a breathtaking facility. In 1971 he learned that the cathedral would be looking for a sculptor to adorn the entire west facade. The theme was to be the Creation, with the *pièce de résistance* a two-story-high, twenty-one-foot-wide stone bas-relief above the main entrance. Morigi urged Hart to enter the competition. The young would-be sculptor spent three years conceiving and preparing a series of scale models. In 1974, at the age of thirty-one, a complete unknown, a stone carver by trade, Hart won what would turn out to be the most monumental commission for religious sculpture in the United States in the twentieth century. He spent ten years creating the full-size models in clay and overseeing Morigi and his men as they carved *Ex Nihilo* (Out of Nothing), depicting mankind emerging from the swirling rush of chaos.

Hart was now at the same point in his career as Giotto when Giotto did his first great painting, the Virgin Mary trembling before the Archangel Gabriel, for the high altar of the Abbey of Florence in 1301. From that time on, Giotto's life was an uninterrupted ascension to wealth, the company and patronage of the rich and powerful, surpassing fame, and the universal admiration of his fellow artists. For Hart, the more earthly rewards came soon enough. In 1982, after a terrific imbroglio in which veterans protested the tombstone-like, antiheroic look of the black wall chosen for the Vietnam Veterans Memorial in Washington, he was commissioned to add a group of three soldiers to the site. In 1985 Ronald Reagan appointed him to the Commission of Fine Arts. In 1994 he completed a statue of Jimmy Carter for the State Capitol in Atlanta and was at work on a statue of the late senator Richard Russell and a statue of Luis Carlos Galan, the Colombian presidential candidate slain by drug cartel assassins, to be erected in front of the presidential palace in Bogotá. By that time, many thousands of his smaller pieces cast in clear acrylic resin had been sold through galleries. Add to this the throngs who came annually to see his *Three Soldiers* and *Ex Nihilo*, and Hart could probably claim the largest following of any living American sculptor.

All in all, an ascension of the Giotto dimension—but one thing was missing: the artistic atmosphere of fourteenth-century Florence, not to mention a Vasari or two to chronicle his success.

Just what this meant Hart found out in the very first week after the dedication of *Ex Nihilo* in 1982 (two years before the completion of the entire facade). In the press, even the local press, there was nothing, save a single rather slighting remark in passing in the *Style* section of the *Washington Post*. In the art press in the weeks and months and years that followed—nothing, not even so much as a one-paragraph review. Thirteen years at work on the most important American religious commission of the twentieth century, and—*nihil*, a hollow silence. The whole of mankind was emerging above the west portico, but in the press the sculptor and his triumph never made it *ex nihilo*. It was as if the west side of Washington National Cathedral, the seventh-largest cathedral in the world, was invisible.

But why? As Hart was now able to figure out at his leisure, by the 1980s all work in the Giotto tradition of glorious lifelike human forms, not just his, was being buried in the most ludicrous collapse of taste in the history

of the American art world. In the case of sculpture, specifically, matters had plunged to the level of outright farce. The American art "world", as it was known, was in fact a small network of dealers, museum curators, collectors, and established artists who created and certified reputations. In 1976 the author of the seminal book on the subject, *The Painted Word*, estimated their number at no more than 3,000 souls nationwide, of whom about 2,700 lived in New York City or nearby. The American art "village", he called it with telling accuracy—and yet art critics everywhere, even in the popular press, were content to serve as obedient little subalterns conveying the village's decisions to the public at large. In the 1940s this network was swept by a vogue for abstract art. In the 1950s and 1960s American corporations began building glass towers with bare concrete and granite plazas out front, and in the plazas they began placing abstract sculptures, the favorites being twisted extrusions in the Isamu Noguchi manner and boluses with holes in them à la Henry Moore. Among architects this came to be known as the Turd in the Plaza school of sculpture, after a remark by James Wines, who said, "I don't care if they want to build those boring glass boxes, but why do they always deposit that little turd in the plaza when they leave?"

In the 1970s and the 1980s the art bureaucrats—from such government creations as the National Endowment for the Arts' Art in Public Places program and the General Services Administration's Art-in-Architecture program—came into their own and started promoting the village's latest fashion, "the sculpture of object-ness" (in which sculpture was not supposed to evoke, much less represent, anything other than its "weight" and "gravity" as an object). This led to one howler after another. The bureaucrats kept commissioning large public sculptures that the public loathed, even to the point of going through protracted administrative hearings and court battles to have the loathsome objects, in all of their grave and weighty object-ness, removed. The howler of all howlers came in 1976, when the City of Hartford, Connecticut, approached the National Endowment for the Arts to put up part of the money and find a sculptor to provide a major work for a choice site downtown to celebrate Hartford's eminence as the Athens of western south-central New England. In due course a man named Carl Andre arrived with thirty-six rocks, huge rocks but just plain rocks from off the ground, and had some unionized elves arrange them in a triangular pattern, like bowling pins. He then presented the City Council with a bill for $87,000. While the citizens hooted and jeered and called them imbeciles, the councilmen tamped the sides of their heads with heels of their hands—and, prodded by the National Endowment for the Arts, paid up.

Vasari attributed all remarkable developments in art history to God. He said that God sent Michelangelo to earth to perfect the art of Florence, and Raphael to prove that a genius among artists could also be a perfectly polite and cultivated gentleman. If he was right, then God sent Carl Andre to Hartford to prove the correctness of the British playwright Tom Stoppard's crack, "Contemporary art is imagination without skill".

In the wake of the Hartford fiasco and many similar ones in the 1980s, Hart and other representational sculptors began to believe that the collapse of taste had finally hit bottom and that a rebirth of figurative sculpture—and skill—must be at hand, even in the New York art village. After all, the Giotto tradition was not dead. It was merely invisible to the village and its subalterns in the provinces. There were still plenty of municipal, institutional, religious, and civic leaders who, wanting to pay tribute to great themes or great individuals, bypassed the art bureaucracies and turned

14

directly to sculptors with skill, skill in portraying the idealized human form, to do it. Prime examples were Hart's *Ex Nihilo*, Raymond Kaskey's *Portlandia*, in Portland, Oregon, Audrey Flack's *Civitas* at Rock Hill, South Carolina, and Eric Parks' *Elvis Statue* (1980) in Memphis.

The public loved the figures they produced, reveled in them, sometimes with startling displays of emotion. When Kaskey's *Portlandia*, a colossal figure of a woman in a toga, arrived in Portland by barge on the Willamette River in 1985, thousands of citizens lined the shore and boulevards, cheering and crying. Parents lifted their children up so they could touch the bronze goddess' outstretched fingertips. The art press, however, continued to ignore such work, as did the museums and major galleries. And so did the art schools. By 1994 there were only half a dozen offering full-scale curricula in the sculpting of the human form. Eighty years ago no sculpture department would have offered anything else.

In 1993 Hart began convening a group of artists, scholars, philosophers, and poets at his home in Virginia to try to create a new aesthetic for the arts generally. They go by the name of the Centerists, but their thinking parallels that of a broader movement known as the Idealist school of contemporary representational art. One of the major theorists is Pierce Rice, who argues in his book *Man as Hero* that the great tradition of Western art has been, and should continue to be, not merely representational work but the idealization of the human form, the glorification of both heroic individuals and the heroic possibilities of mankind. At bottom, Idealism rests upon a religious assumption taken for granted in the Renaissance, namely that human beings are created in the image of God.

Within the New York art village such a notion is so *infra dig*, the dealers, curators, collectors, and artists who establish fashions don't even bother to condemn it. They avert their eyes. It is . . . in *such poor taste.* The tasteful view today is precisely the opposite and, as the Idealists see it, bears out a prediction Nietzsche made just over a hundred years ago when he announced that God was dead. Men no longer believed in God, he said, but they had not shed their own sense of guilt. So henceforth they would still feel guilty but would have no one to turn to for forgiveness, causing them to loathe themselves and one another. As a result, the twentieth century would be a century of wars catastrophic beyond all imagining, waged by human beings who looked upon their loathsome selves as no different, morally, from other beasts—mere organisms, one and all, driven on by urges and appetites but constantly starved for meaning in their lives.

Over the past five years, the art village, the network, has begun to sanction a form of figurative sculpture sometimes called I.C.U. Art (for intensive care unit), in which self-loathing and loathing of the human species reach a nadir, from the Idealist point of view. Typical creations of I.C.U. sculpture are the incinerated and flagellated corpse of a tiny woman with her bloody spinal column popping out through the skin of her back ( Kiki Smith, *Untitled*, 1992); a bowl of plums, each plum possessing a screaming human mouth with purple lips and gnashing purple teeth (Rona Pondick, *Plums*, 1993); the lower half of the torso of a man wearing tightywhitey undershorts, ribbed socks, and Topsider sneakers with gaping holes in his legs and left buttock that look like crosses between abscess craters and plumbing drains (Robert Gober, *Untitled*, 1991); and the blackened figure of a man with no eyes, no nose, no mouth, no ears, hogtied in a jackknifed position (Antony Gormley, *Proof*, 1984). By 1994, the loathing of Homo sapiens among the fashionable sculptors had reached such an inten-

sity that a University of Chicago art historian, Barbara Maria Stafford, was driven to ask: "Why, in order to be serious, do things have to be ugly?"

Young sculptors with skills and aspirations resembling Frederick Hart's find themselves in a bind—felt even at the handful of art schools where figurative sculpture is taught. Do they choose the fashionable direction, which at the moment is I.C.U. Art? True, it demands an appetite for the ugly and requires (and tolerates) only minimal skill, but it at least holds out the possibility of being taken seriously by the art worldlings who certify reputations. Or do they choose Idealism, with its guarantee of . . . *eyes averted* . . . perhaps for a lifetime?

As for Hart himself, his career is very likely fireproof. If recent history is any indication, those who want to celebrate Homo sapiens' hopes and feats will continue to seek out his surpassing skill at bringing alive the human form in the tradition Giotto introduced with his models for the campanile of Santa Maria del Fiore, and people will love it. Repeatedly over the past ten years, the public has demonstrated not merely its preference but its passion for the work of the Harts, the Kaskeys, the Flacks, and the Parkses. The question is whether public pressure will at last crack the art world's much-loathed New York Wall of taste or merely harden it.

# WASHINGTON NATIONAL CATHEDRAL

## A PORTFOLIO

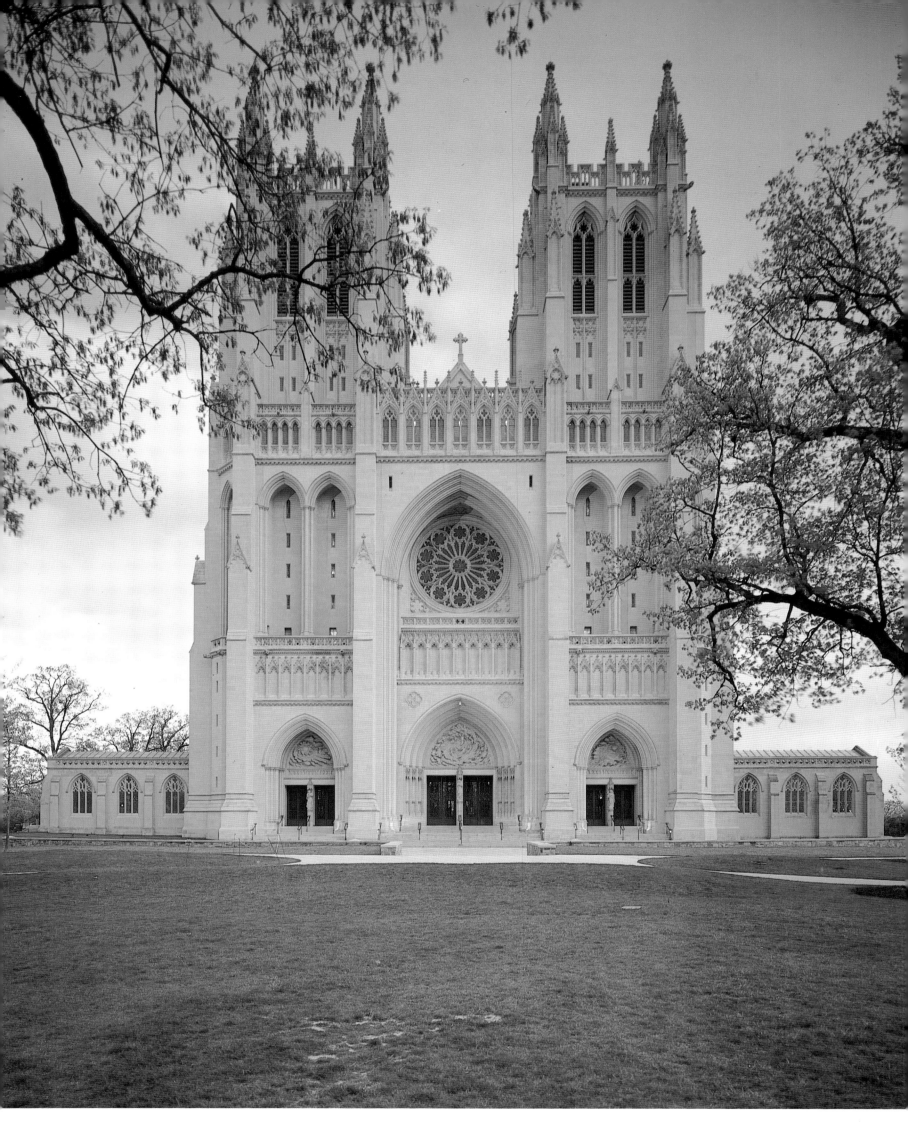

*Washington National Cathedral, Washington, D.C.*

# Metamorphosis:
## Stone Carver to Artist

# HOMAN POTTERTON

Frederick E. Hart, an American artist whose work has evolved out of a distinctly European sculptural tradition, realized the earliest flowering of his artistic achievement in the carved portal of Washington National Cathedral, the last great Gothic cathedral ever built. This is entirely appropriate, for it was with the construction of the magnificent Romanesque and subsequent Gothic cathedrals of western Europe that the sculptor-as-artist reemerged as an individual for the first time since antiquity.

From the eleventh century onward, at Cluny, Chartres, Strasbourg, and Rheims, schools of sculpture sprang up around the great cathedrals. At first, the craftsmen who worked together at these sites were masons who executed the highly technical feats of construction required by Romanesque and Gothic architecture. Gradually, the process of building gave way to that of decorating. They developed into artist–stone carvers, creating the capitals of the columns that supported the arcades that were one of the distinguishing features of medieval church architecture. Eventually the capitals, which often began as whimsical interpretations of the Corinthian type, which had survived from Roman times, became an integral part of the architecture. By the end of the eleventh century, at the celebrated Abbey of Cluny, for example, sophisticated iconographical programs were being sculpted by individual artists of the highest caliber. Thus the mason evolved into the craftsman, the artist–stone carver, who became a sculptor.

Frederick Hart's training and artistic development followed the medieval pattern. After studying and working with Heinz Warneke, Carl Mose, and Felix de Weldon, Hart migrated to Washington National Cathedral, where he became apprenticed to veteran Italian stone carver Roger Morigi (b. 1907). "Roger Morigi taught me what truly makes sculpture work", the artist said. "He was basically a stone carver but he had the soul of an artist—a meticulous craftsman. The cathedral became a magical place for me, a place outside this century. The wonderful Italian stone carvers who worked there were the last sliver of a generation, a link back to the major American architectural world of the early 1900s . . . as well as to the great American sculptors Augustus Saint-Gaudens and Daniel Chester French. Working at the cathedral was the best experience of my learning life. It taught me 'how' to work. I wanted to know and feel the discipline—the mastery of stone carving—and I learned that in the hours of working up on the scaffolding in the heat of summer and through the winter."

Homan Potterton, former director of the National Gallery of Ireland and current editor of the *Irish Arts Review Yearbook*, is the author of a book on the American sculptor Andrew O'Connor.

19

*Hart working on clay* Erasmus

*The Churchill-Marlborough
Coat-of-Arms
label mold termination*
18a

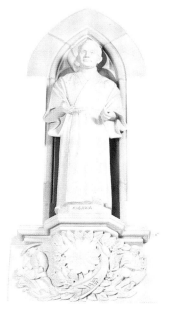

*Toyohiko Kagawa
niche figure*
34

From 1967 onward, Hart worked at Washington National Cathedral much as the stone carvers of medieval Europe had worked, fashioning decorative elements in stone from the architect's drawings. Then he graduated to the more highly skilled task of chiseling specific reliefs, ornamental motifs, and even gargoyles. By 1971 Hart had created the models for the figure of Erasmus on the outer aisle of the south nave, more than two dozen bosses, a dozen label mold terminations, and ten gargoyles. Thus, when it became known that the cathedral building committee had decided to proceed with the plans to build the west portal—the principal entrance—Hart was well qualified to submit some design proposals of his own.

The English architect G. F. Bodley, who had been a pupil of one of the most prolific and famous of all nineteenth-century architects, Sir Giles Gilbert Scott, designed Washington National Cathedral in association with Henry Vaughan of Boston. Bodley's design was later taken over by Hubert Philip Frohman. It was Hart's portrait bust of Frohman that drew the admiration of Richard T. Feller, who, as Clerk of the Works, administered the construction, selection, and installation of art works at the cathedral for thirty-seven years, beginning in 1956. Following the canons of Gothic architecture that had inspired Bodley and Frohman, the design guidelines drawn up by the dean, clerk of the works, architect, and building committee provided for a great tripartite west portal, comprising three doors surmounted by tympana and supported in the center by columnar figures. This tripartite arrangement originated in the early twelfth century with the exquisite triple portals of Moissac, Autun, and Vezelay. The development of the tripartite form over succeeding centuries provided the medieval sculptor with rich opportunities for expression, especially in the carving of tympana. Biblical narrative subjects have decorated elements of medieval architecture other than tympana, but the expanded form of this particular element allowed sculptors the room to create iconographically complex theological programs. Their subject matter was often drawn from the Revelations of Saint John the Divine—as in the Apocalyptic Vision on the south portal at Moissac. The most favored themes for the west portals were the Last Judgment with the Resurrection and the Fall of the Dammed, and, by the high Gothic period, Christ or the Virgin (at the center) flanked by works of sculpture that relate the story of Christ's death, the Resurrection, and the Second Coming.

Long before Frederick Hart began working at the cathedral, the building committee had made the decision to break with tradition and forgo the Last Judgment episode on the west front. Instead, they had selected the more celebratory theme of the Creation, which is the subject of Rowan Le Compte's west rose window above the central door. Several visual prototypes of the Creation theme are found in medieval sculpture and stained glass; among the most celebrated representations of the theme are Michelangelo's frescoes on the ceiling of the Sistine Chapel. All of these antecedents, however, follow the literal description of the creation from the Book of Genesis, where God created the world in six days, beginning with the separation of light from darkness, and culminating on the sixth day with the creation of man. The world that God made in the Book of Genesis was flat, however. It was static, and it was the center of the universe, while the man he created, Adam, fashioned from clay, was living. (Hart correctly realized that such a medieval or Renaissance interpretation would be an anachronism, so he considered how the origins of the earth

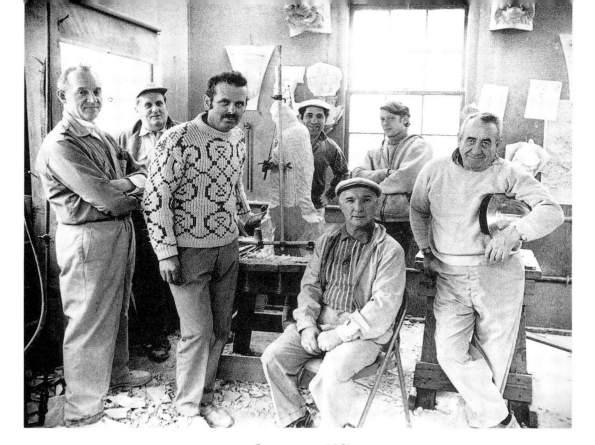

*Stone carvers, 1969*
*Left to right: Frank Zuchett, Frank Zic, Constantine Seferlis, Vincent Palumbo, Roger Morigi,*
*Hart, John Guarente*

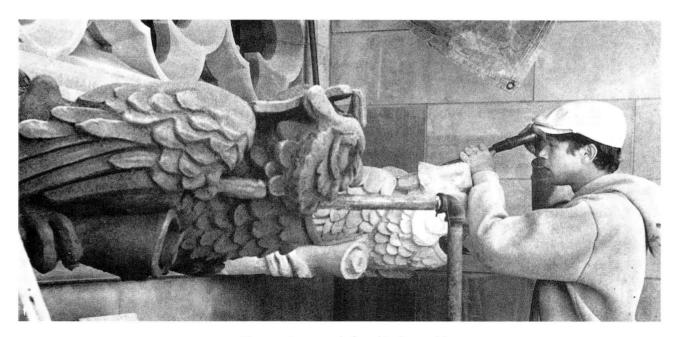

*Hart carving gargoyle from his clay model.*

Pan *gargoyle*
29

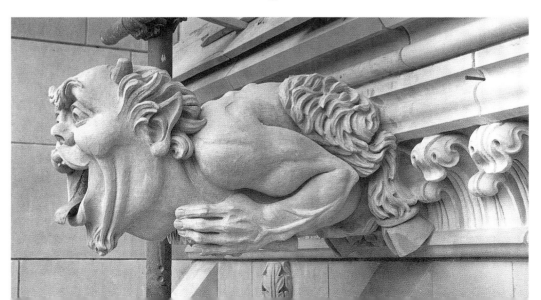

and man might be given form in a manner meaningful in the late twentieth century. "I chose the theme of metamorphosis—plants and figures taking form, emerging out of a sea of nothingness to symbolize the concept and the act of creation; chaos transformed into order, nothingness into reality.") The committee invited five prominent sculptors from the United States and Europe to submit designs, but Feller insisted that Hart, too—who was relatively unknown—must be allowed to enter the competition. The committee rejected Hart's first proposal, as it had the other five designs. His second proposal was accepted on 4 April 1975. In his approach he was inspired by the thinking of the French Jesuit theologian and philosopher Pierre Teilhard de Chardin, who synthesized evolutionary theory and Christianity. Teilhard's perspective, though shunned by the Catholic Church, gained widespread acceptance following its publication in the 1950s in *The Phenomenon of Man* and *The Divine Milieu*. (See the essay by Frederick Turner in this volume.)

The production of the cathedral works required five successive stages, during each of which Hart more fully developed the thematic, conceptual, and formal aspects. First, he made clay maquettes, approximately eighteen inches high. Second, he enlarged the maquettes to one-third full size, or approximately five feet high by seven feet wide. Third, an assistant used a mechanical device similar to a pantograph to enlarge the one-third-size maquettes to full-size, rough clay models, which, in the case of the *Ex Nihilo* reliefs, Hart then spent two and one-half years finishing. The clay models were then cast in plaster. Last, members of the cathedral stone carvers' guild replicated the sculptures in stone. They worked from Hart's plaster casts in the cathedral studio to copy the figures of Adam and Saints Peter and Paul and, on scaffolding forty feet above the ground, to carve the three tympana *in situ*. Vincent Palumbo, who had succeeded master stone carver Roger Morigi, supervised the complex carving of the central tympanum.

Hart called his central tympanum *Ex Nihilo* (Out of Nothing). Eight life-size figures, some male, some female, are shown in the process of emerging— their eyes as yet unopened to the world that awaits them, and their bodies

*Early study for* Ex Nihilo

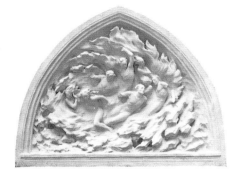

*Winning design for* Ex Nihilo

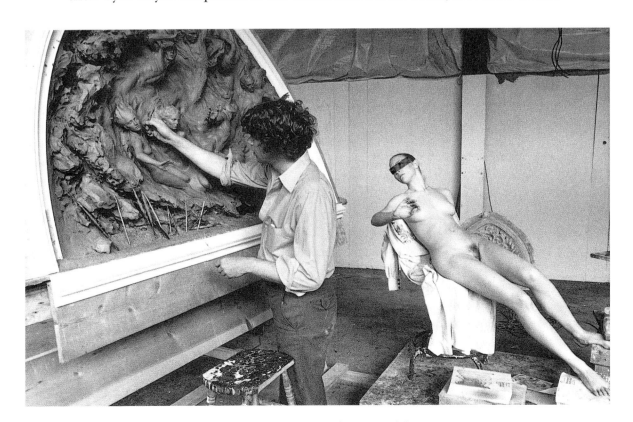

*Working on the one-third-size* Ex Nihilo

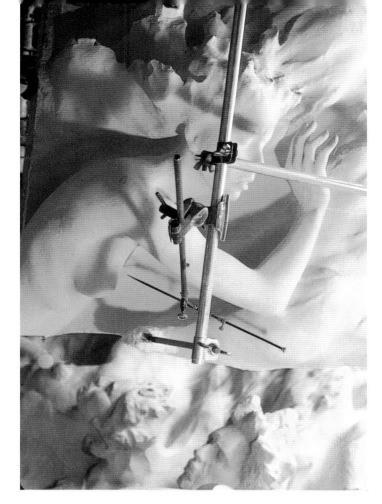

*Carving* Ex Nihilo, *using the pantograph*

*Modeling* Ex Nihilo

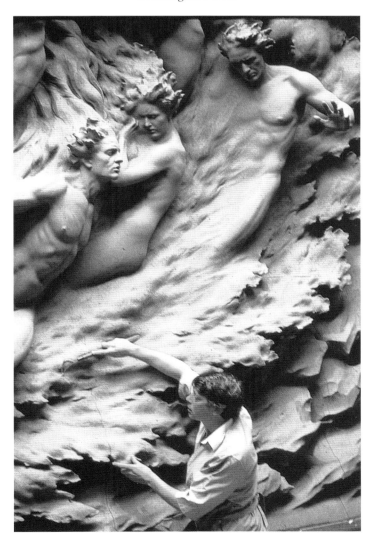

23

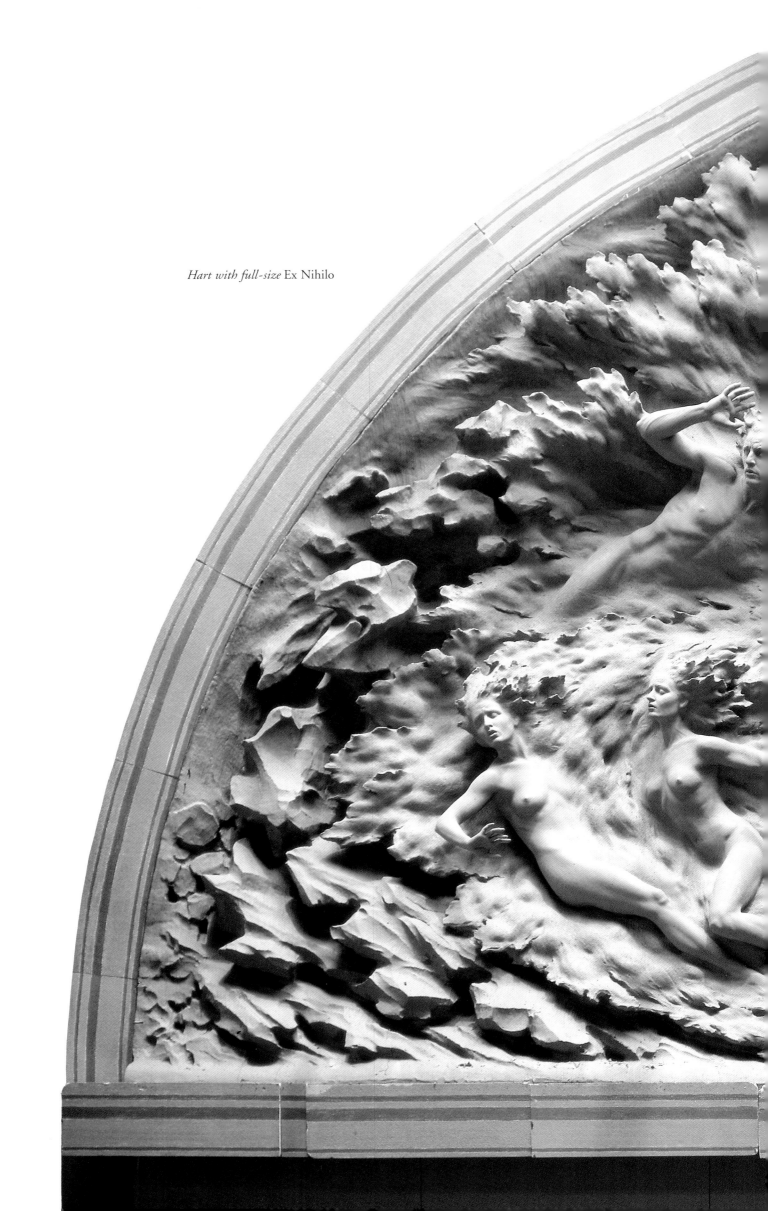

*Hart with full-size* Ex Nihilo

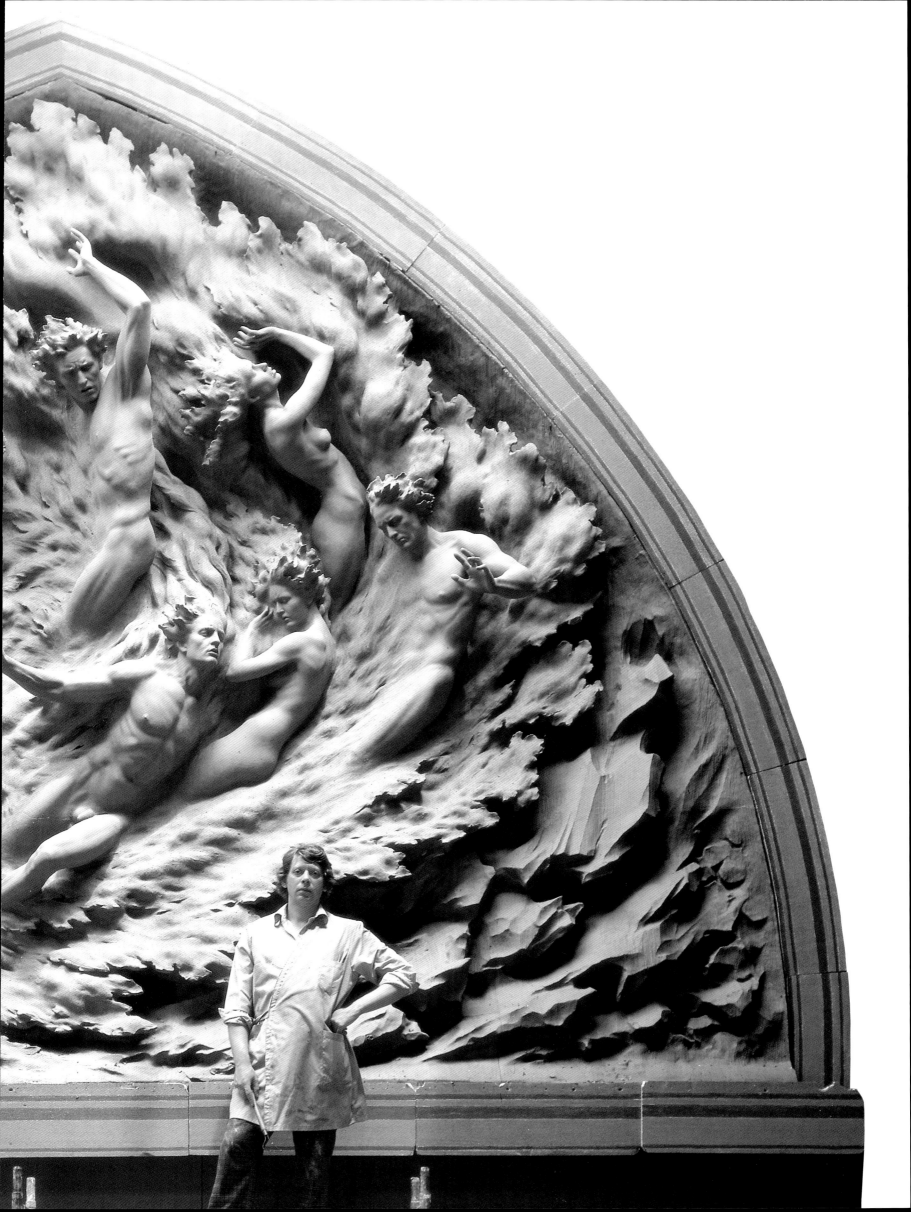

not yet fully formed—from what Hart has described as a "primordial cloud". Part rock, part water, part vegetation, this lyrically conveys a "sense" of creation: a background of fluttering movement that catches and uses the play of light, enhancing the sense of order being created from chaos, which is the overriding concept of the whole. While the idea and placement of the sculpture in the Washington tympanum derives from the Romanesque, when sculpture was an essential element of architecture, the form of Hart's chiseled stone figures in high relief is anything but medieval. In the Middle Ages, sculpted scenes were made up of individual carvings placed together, but Hart's tympanum figures, carved from Indiana limestone, are conceived and executed as a unified whole. In this respect they may be considered to have their origins more in the carved marble or modeled reliefs of antiquity and the Renaissance, rather than in the sculpted images of the Gothic.

*Georgetown studio, 1976*

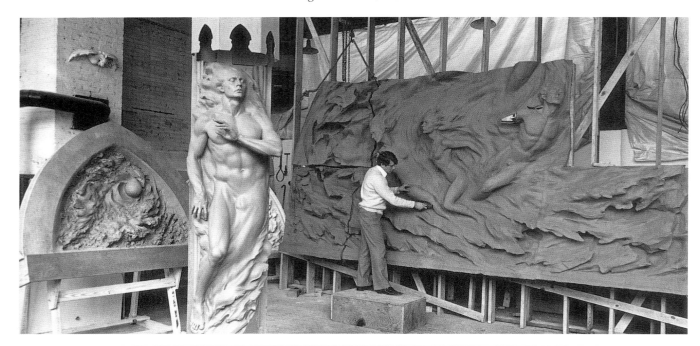

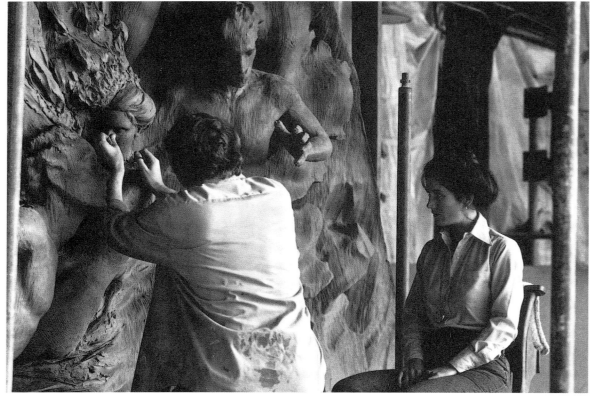

*Lindy Lain, soon to be Mrs. Frederick Hart, posing
for* Ex Nihilo

*Plaster casters Cesare and Victor Contini casting*
Creation of Night

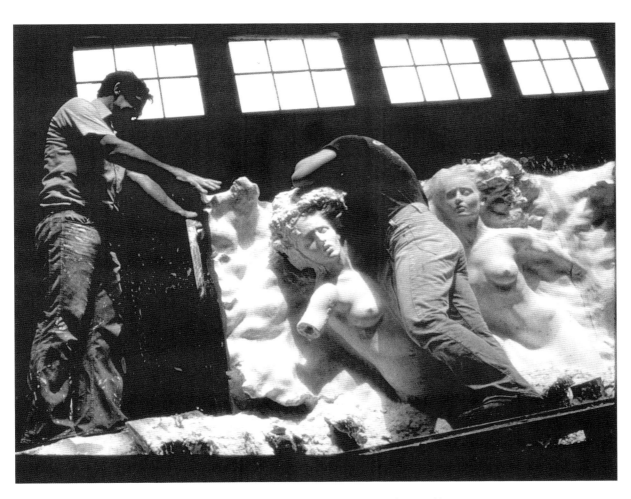

*Bruce Hoheb, plaster caster, with assistant, disassembling
the cast* Ex Nihilo *to transport it to the cathedral*

*Master carver Vincent Palumbo and Hart viewing the stone face
where* Ex Nihilo *is to be carved*

EX NIHILO
42

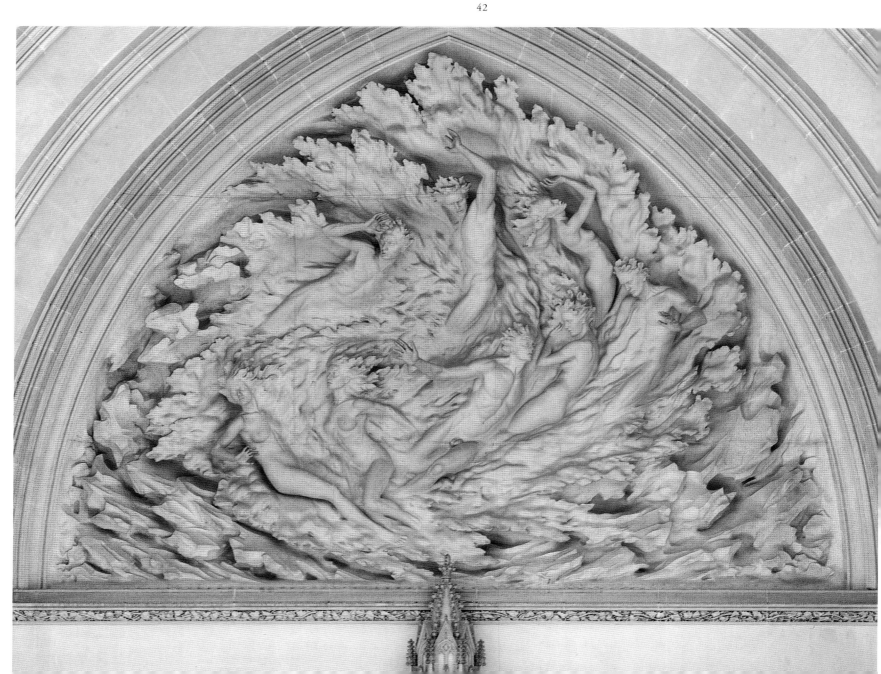

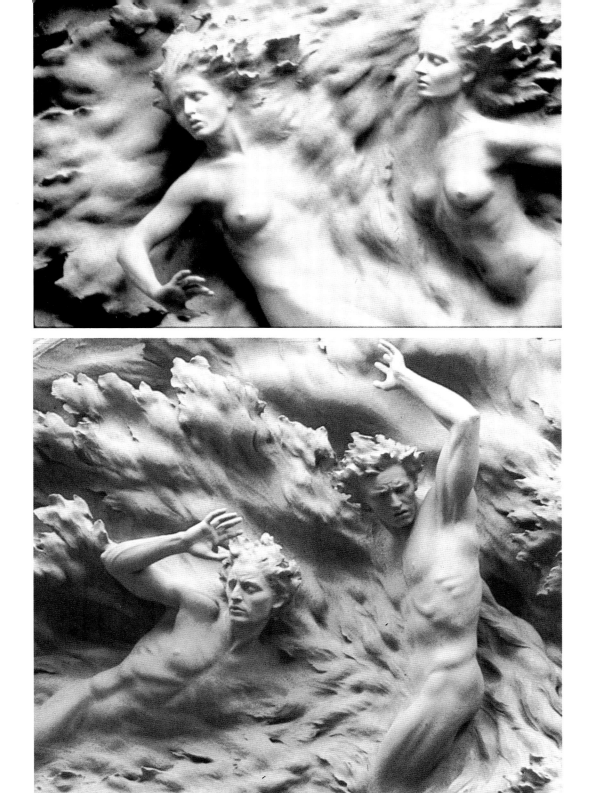

Ex Nihilo *details*

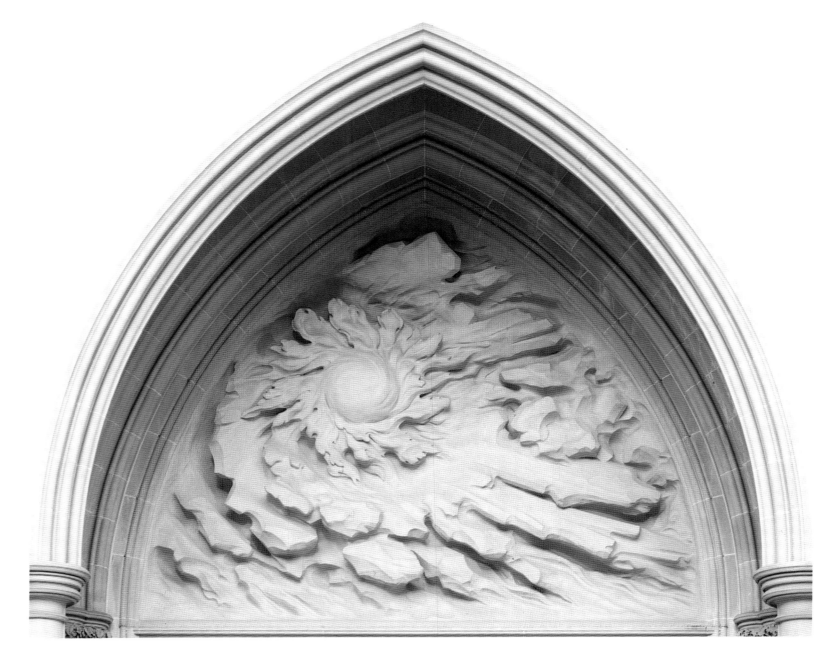

CREATION OF DAY
49

Flanking the center tympanum are the smaller works above the north and south doors: one depicts the creation of day, the other, the creation of night. God, again according to Genesis, created day and night by separating the light from darkness—the same scene depicted by Michelangelo on the Sistine ceiling—but Hart, without the use of any human forms, shows "Day and Night not as nouns, but as verbs, not static depictions but events in the state of becoming—Day and Night as polarities of creation".

Completing the sculptural program on the west portal are three life-size, full-length figures: on the north and south doors, Saints Peter and Paul—to whom Washington National Cathedral is dedicated—and on the center door, Adam. These figures, perched high on plinths and beneath finely carved Gothic canopies, form the central and supporting columns of each doorway. They owe their origins to Spanish Romanesque column figures, which inspired French Romanesque portals and finally developed into freestanding figures before the column figure emerged as a type at Saint-Denis about 1140.

The invention of the column figure opened up new opportunities for sculptors, and by the thirteenth century, with high Gothic, this type had attained perfection. At the Gothic cathedrals of Amiens and Rheims, for

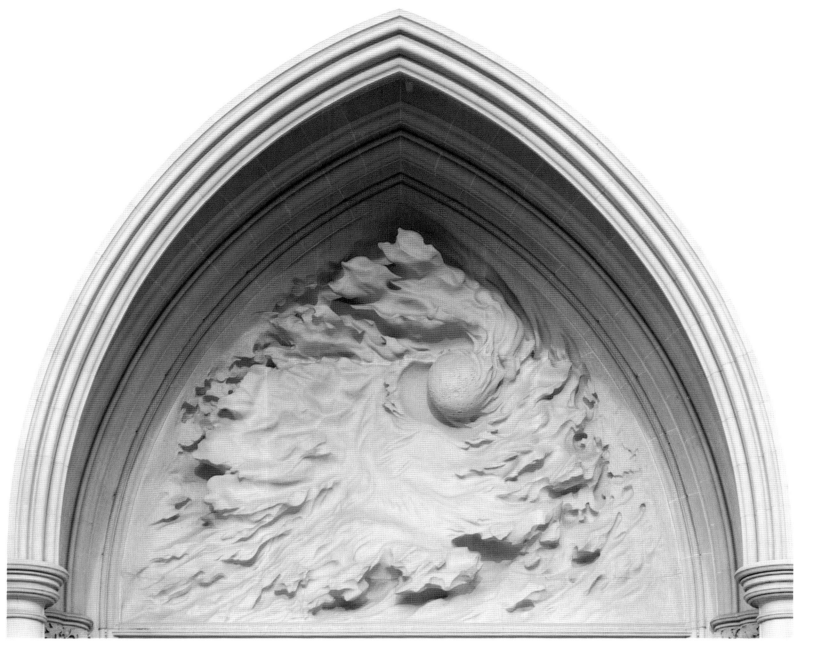

CREATION OF NIGHT
46

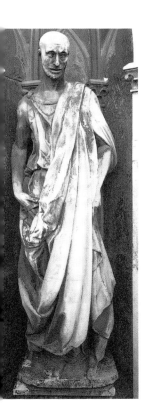

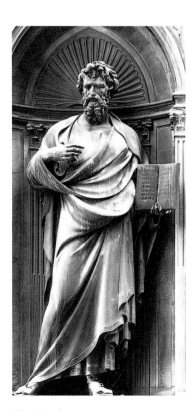

example, both of which date from the mid-thirteenth century, the column figures are freestanding, their space defined by the canopies above them, and their demeanor is greatly more human and lifelike than in the Romanesque period: the figures seem to speak to one another, if not to the viewer. In Italy, in the late Gothic and early Renaissance periods, the column figure emerged as a statue in notable works executed by various sculptors—among them Donatello and Ghilberti—for the cathedral and for San Michele in Florence. These masterpieces, showing various prophets and saints standing full-length and clad in togas, became the prototypes from which all subsequent full-length statues of saints derived. In comparison to Hart's Washington National Cathedral work, they owe much more to the antique, while Hart's highly charged saints, Peter, Paul, and Adam owe more to baroque seventeenth-century Italian art.

*Adam*, the central column figure beneath the *Ex Nihilo*, seems to emerge from the mass of stone. Like the figures above him, his eyes are closed, and he appears to soar upward, the blood rushing through the veins of his muscled arms and hands. This, according to Hart, is "the finite *individual* man, the Everyman—the concrete embodiment of all aspects of the work. He is the old Adam, the figure emergent from chaos, shaped by

*Donatello,* The Prophet Habakkuk,
*Museum of the Duomo, Florence*

31

*Ghiberti,* St. Matthew,
*Orsanmichele, Florence*

the potter's hand, the passion and the zenith of creations. . . He is also the *new* Adam, emergent, radiant in light. He is at once absolutely concrete and absolutely universal . . ."

In one of the most familiar images of all Western art, Michelangelo, too, depicted the creation of Adam; but his languid model, reaching out in expectation for the touch of God the Father, is very different in feeling from the awakening presence that is Hart's *Adam*. Consciously or not, though, Hart pays homage to Michelangelo in the pose of this figure: the torso, the tensely modeled leg, and the gesture of the left arm and hand recall the youthful, nude Christ who is the central figure of Michelangelo's *Last Judgment* fresco in the Sistine Chapel.

At Washington National Cathedral the column figures of the patron saints Peter and Paul on the north and south doorways of the west portal are enormously powerful. Both saints are depicted at the precise moments of their conversions. For that reason Saint Peter is shown, not with his usual attribute of a bunch of keys—the keys to Paradise—but, instead, with a fishnet over his shoulder, perhaps at the exact instant on the Sea of Galilee when Jesus called him and Saint Andrew to follow Him as "fishers of men". Saint Peter's calling was an awakening—an eye-opening—and it is therefore appropriate that he is the figure placed beneath the tympanum that represents day—the light as it were. It is noteworthy that *Saint Peter* is the only figure on the west facade whose eyes are open. Underneath night is *Saint Paul*, his eyes closed to the darkness, but more precisely temporarily blinded as he was at the time of his conversion on the road to Damascus. In his left hand he carries his usual attribute of a sword—the weapon with which he was beheaded at the time of his martyrdom. Breaking out of their restraining niches, the three figures of Adam, Peter, and Paul have enormous emotional appeal and exemplify one of Hart's dicta: "I don't think of myself as an architectural sculptor but as a sculptor using architecture as a medium . . . and a structure like the Cathedral is the finest medium there is. Sculpture should not just be *viewed*, it should be *experienced* by an audience".

*Vincent Palumbo roughing out* St. Paul *in stone*

ST. PETER
48

ADAM
35

ST. PAUL
47

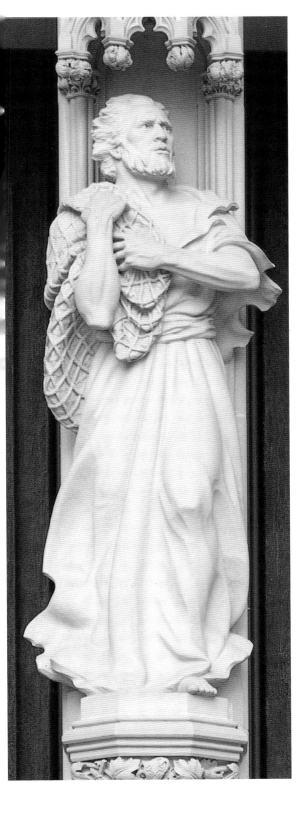
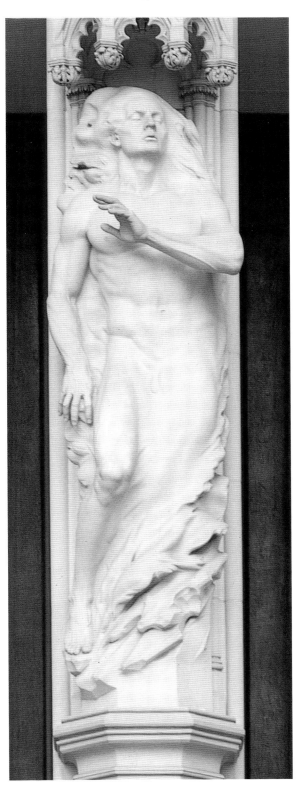
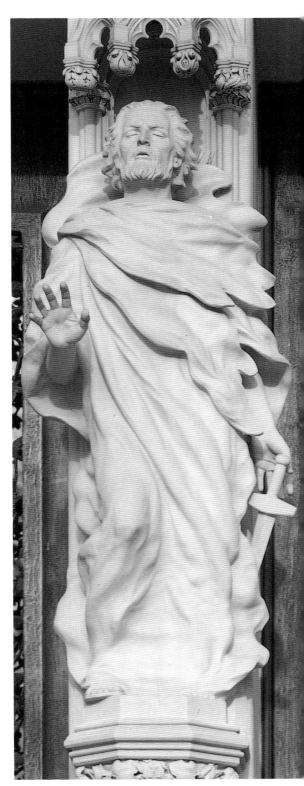

*Robert Parke posing for* Adam,· *1976*

I see Adam as Everyman,
pulled from the waters of baptism.

FREDERICK HART

Hart has perfected the techniques practiced by the sculptors of the Middle Ages, the Renaissance, and antiquity (see the essay by James M. Goode in this volume, page 43); but his art is far more than the sum of these techniques. His emotional and intellectual response to the theme of the Creation has led Hart to explore the possibilities of a new material, clear acrylic resin, as a vehicle for conveying his ideas, sculpting, as it were, with light (see the essay by Robert Chase in this volume). It seems as though Hart's earlier sculptures was all in preparation for his latest work in Lucite. In the Creation series he sought to represent a metamorphosis, a sense of forms emerging out of mass. In the Lucite works a theme takes realistic form while retaining a spirituality as the result of the ethereal qualities of the medium. This work, like his work at Washington National Cathedral, is as awe-inspiring as the most sublime sculpture in the history of Western art.

*Detail of* Adam *clay mode.*

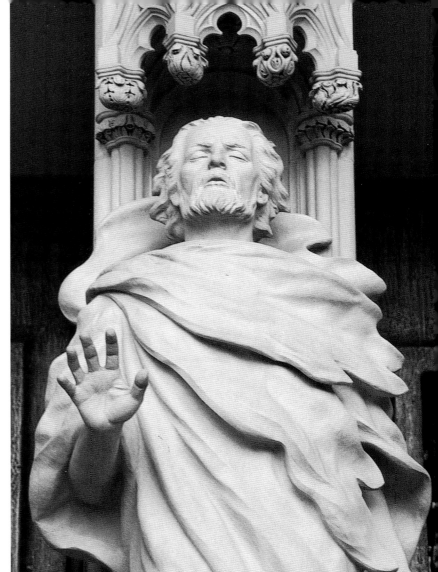

*Details: below:* Adam
*right top:* St. Paul
*right bottom:* St. Peter

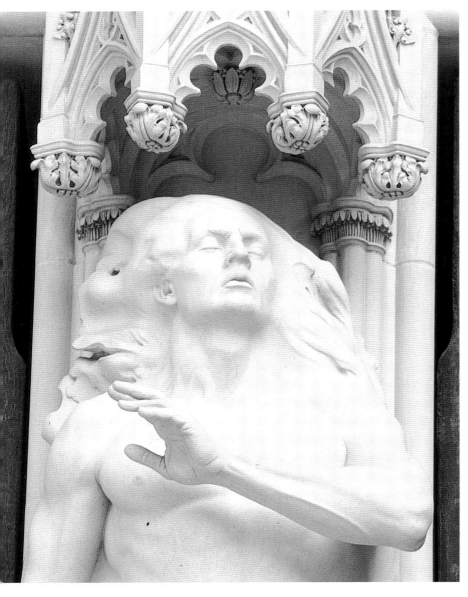

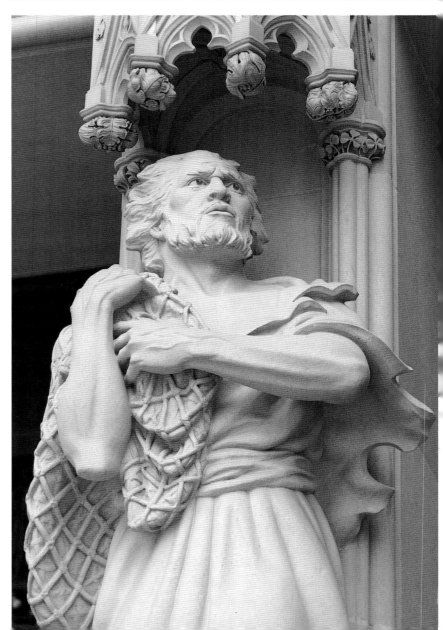

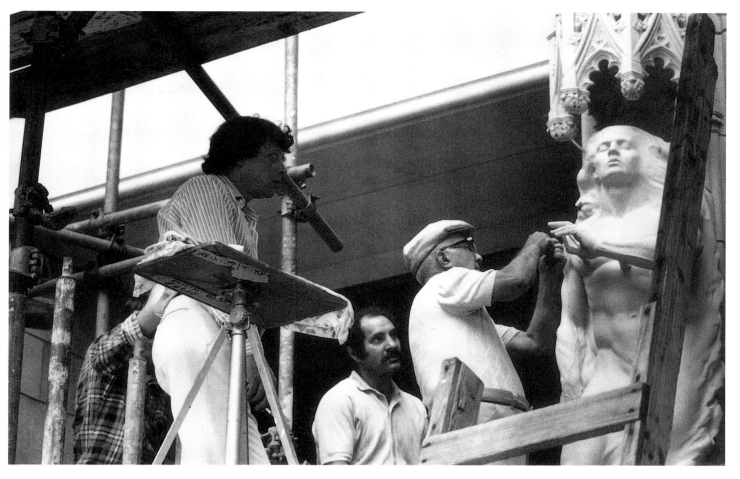

*Hart, Vincent Palumbo, and Roger Morigi installing* Adam

*Celebrating the installation of* Adam. *Clockwise, from left: Jay Carpenter, Hart's assistant;*
*Frank Zic, carver; Roger Morigi; Louise Morigi; Howard Trevillian, assistant architect;*
*Patrick Plunkett, stone carver; Vincent Palumbo; Carl Tucker, model maker; Hart.*

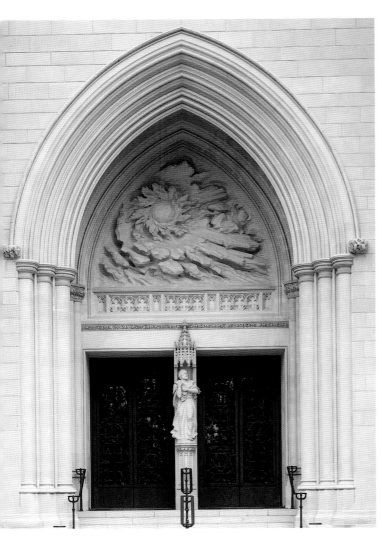

*Entrance with* Creation of Day *and* St. Peter

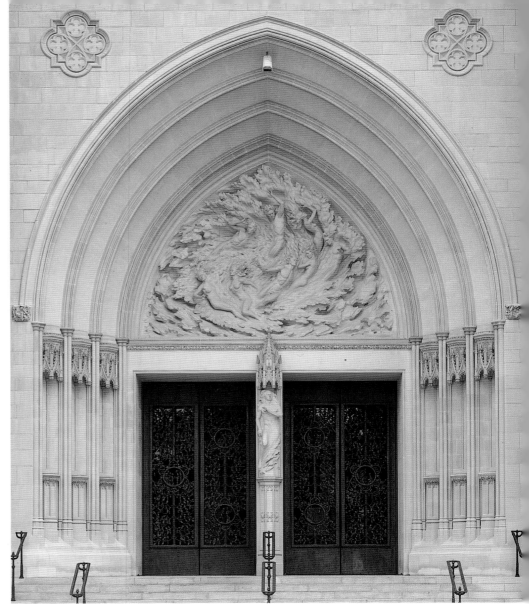

*Entrance with* Ex Nihilo *and* Adam

. . . It is without question the major architectural sculpture of our day. It is the most important artwork in the Washington Cathedral of the nation's capital . . .

SARAH BOOTH CONROY
in *Horizon*

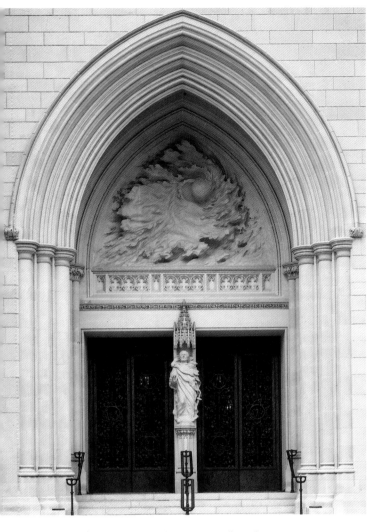

*Entrance with* Creation of Night
*and* St. Paul

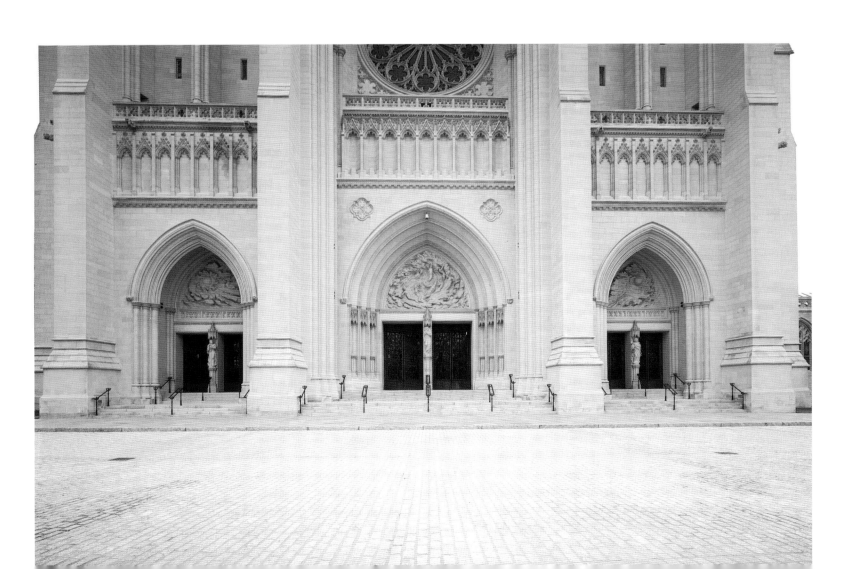

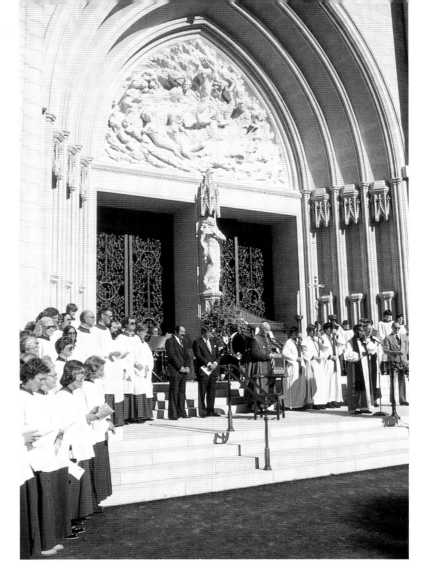

*Dedication of* Ex Nihilo, *October 2, 1982*

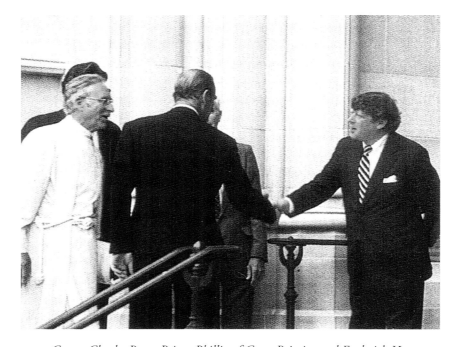

*Canon Charles Perry, Prince Phillip of Great Britain, and Frederick Hart*

# THE
# VIETNAM VETERANS
# MEMORIAL

## A PORTFOLIO

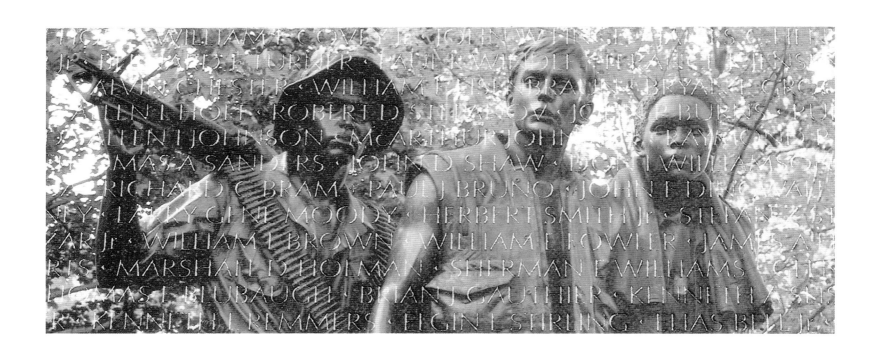

# Three Soldiers: *A Solution to a National Controversy*

## JAMES M. GOODE

The nation's capital boasts a rich and important collection of figurative public sculpture—much of it dating from the second half of the nineteenth century and the first half of the twentieth century. In spite of the widespread preference in the United States since the 1940s for modernism and the international style, numerous examples of figurative public sculpture have been commissioned in Washington in the last decade.

Among the works in this category are *The Lone Sailor* by Stanley Bleifeld, part of the Navy Memorial at Market Square; the four groups of bronze lions at the National Law Enforcement Officers' Memorial by Ray Kaskey at Judiciary Square; and Barry Johnston's *Wedlock* at 20th and L Streets, N.W. Even now, the Korean War Memorial, with figures by Frank Gaylord, is under construction near the Lincoln Memorial on the Mall.

Without doubt, though, the most significant works to grace public spaces in Washington are by a single artist, Frederick E. Hart. His three trumeau figures and three tympana at Washington National Cathedral interpret the theme of the Creation, discussed earlier in this book. A more recent work, a bronze group of three soldiers (1984), is part of the Vietnam Veterans Memorial at the west end of the Mall. Although the themes, media, and artistic antecedents are very different, the two projects are distinguished by animated compositions, attention to detail, and formal beauty. They are good examples of how public art can serve vastly different purposes.

The desire for a Vietnam Veterans Memorial on the Mall began in March 1979, when Jan Scruggs, a twenty-nine-year-old veteran and resident of the Washington metropolitan area, was moved by the portrayal in the film *The Deer Hunter* of the suffering endured by American servicemen during and after the Vietnam War. Scruggs was a rifleman in the 199th Light Infantry and had experienced the horror of seeing half his company killed or wounded in a battle in March 1969. Soon after, he was badly wounded by an exploding rocket grenade. Scruggs and several other veterans, including John Wheeler and Robert Doubek, founded the Vietnam Veterans Memorial Fund. Their early efforts were supported by James Webb, a Vietnam veteran who later became Secretary of the Navy. Their group became the voice for many of the nation's three million Vietnam veterans, who were deeply hurt by what they perceived as public antipathy toward them, because the war had been unpopular and, more to the point, the United States had lost. The veterans felt that the nation owed them a debt of gratitude, which could be best expressed by a memorial on the national mall.

By 1980 the idea of a memorial had gained momentum. Senators Charles

James M. Goode, former curator of the Smithsonian Institution Building, is the author of several books on the sculpture and architecture of Washington D.C.

Mathias of Maryland and John Warner of Virginia cosponsored the bill to designate a site between the Washington Monument and the Lincoln Memorial, which led to approval by the House and Senate, and President Carter signed the bill on 1 July 1980.

Subsequently, the Vietnam Veterans Memorial Fund sponsored a national competition for the design of the memorial. Guidelines specified that the memorial must be contemplative, respect the site, abstain from making any political statement, and include the inscribed name of each of the 58,000 dead and missing. Maya Ying Lin, a twenty-one-year-old Yale University architecture student, submitted the abstract, simple design that was chosen from among the 1,421 entries. The design jury included twenty individuals, none of them a Vietnam veteran. Lin's plan was for a V-shaped, polished black granite wall cut into the ground, only ten inches high at each end but increasing to a height of ten feet at its center. Lin's arrangement of the names was symbolic: the first to die, in 1957, were to be inscribed at the apex, at the beginning of the right-hand side and continuing in chronological order to the end of that side of the wall. The list would resume at the left end of the left-hand side of the wall and terminate with the last death, in 1975, at the apex. Thus the earliest and latest deaths would meet.

Before Lin's design could be realized, the officers of the Vietnam Veterans Memorial Fund were required to have it approved by three government agencies: the Commission of Fine Arts, the National Capital Planning Commission, and the Department of the Interior. Almost immediately, opposition came from veterans' groups and conservatives. Tom Carhart, a veteran and outspoken opponent of the minimalist design, even referred to it as "the black gash of shame". The dissenting veterans wanted a monument that would acknowledge and honor the service of the three million surviving Vietnam veterans, as well as one that would honor the memory of the war dead. These veterans felt that they had served their country as honorably and as faithfully as their forebears had, and deserved a monument that was comparable in its message to other war memorials. (The Lin design pointedly omitted any reference to duty, honor, or sacrifice.) The black, below-ground design aroused a deep sense of resentment and suspicion that the veterans were again being regarded not as heroes, but, at best, as victims.

As the controversy intensified, then Secretary of the Interior James Watt intervened, stating that until all of the participants reached some form of compromise, he would withhold the permit to begin construction on the memorial. A historic meeting, initiated and chaired by Senator John Warner, was held at the Capitol. The result of this stormy, emotional meeting of the opposing groups of veterans was a decision to add a statue or sculpture group and flag to the original design. At the time, all of the parties agreed to the compromise. Among others who attended were Scruggs, Wheeler, Doubek, Lin, and Carhart and Webb.

Yet the compromise eventually generated as much bitter controversy as Lin's original design. Frederick Hart was selected by the Vietnam Veterans Memorial Fund to submit a design for the statue. The precise location of the statue as well as the American flag became a central focus of the controversy. Hart's solution preserved the integrity of the wall, yet situated the figures within the context of the memorial: facing the wall, at the edge of a grove of trees a hundred feet away. The flag would be slightly behind and to the side of the three soldiers.

The architectural firm of Cooper-Lecky prepared the working drawings and directed the construction of the eleven-million-dollar project. With the many design issues settled, crews began building the wall, working toward the deadline of Veterans Day 1982, when the memorial was to be dedicated. It was agreed that Hart would require more time to refine and execute the figure group, and a deadline of 1984 for the installation of the three bronze figures was set. During the construction of the wall, only slight changes were made to Lin's original plan—the length was extended from 400 to 500 feet and a black granite footpath was laid along its angled length. Thousands of Vietnam veterans from across the country attended the dedication ceremonies on 11 November 1982, which included a fifty-six-hour-long reading of the names of the dead and missing at Washington National Cathedral.

Meanwhile, Hart was at work on the untitled group of three figures. He interviewed dozens of Vietnam veterans to learn the characteristics of combat dress and to glean as much as possible of their experience. He watched many documentary films and studied period weapons and ammunition, exploring every available source of information. Hart chose to represent the soldiers as they would have been dressed in the field, wearing an informal mixture of military garments and carrying a variety of weapons. One has a towel around his neck. Another follows the custom of wearing a dog tag laced into one of his boots for good luck. All of the weapons depicted are typical of those used in Vietnam—an M-16 rifle,an M-60 machine gun, and a .45 caliber pistol. Although pistols are generally associated with officers, machine gunners were permitted to wear them in combat for close-range defense.

While, as has been shown, the style of Hart's cathedral works is found in the Gothic, the artistic tradition to which Hart's three soldiers belongs is the classical. The ancient Greeks first mastered the freestanding human form in the fifth century B.C., breathing movement and life into marble. Subsequently, the Romans enhanced the human form by embodying ideas—power, virtue, sorrow, wisdom, valor—conveyed through attributes, stance, gesture, or identifying details. Conceptually, the three soldiers reflect these ideas, drawn from antiquity, about the function of sculpture. The men seem to move as if on patrol. The soldier in the center gestures with his right hand for the others to beware. The soldier wearing a hat touches the leader on the back in a gesture of reassurance and solidarity. Perhaps one of the most poignant and forceful aspects of the figures is the shock evident on the faces of all three—expressing the magnitude of the number of war dead, or the experience of seeing their own names, or those of comrades, inscribed on the wall. The three soldiers' positions range from repose—as in the center figure—to action—as in the figure carrying a rifle. Despite the integration of the three figures, each is an individual. In Hart's own words, ". . . there is about them the physical contact and sense of unity that speaks of bonds of love and sacrifice, and this is the nature of men at war. And yet each one is alone. Their true heroism lies in these bonds of loyalty, in their aloneness, and in their vulnerability." In their faces is evident the "shadow of mortality", made all the more compelling by their youth. Hart's group expresses all this, and many other aspects of the human condition as well: courage, exhaustion, duty, and strength.

Hart's Creation sculptures in stone at Washington National Cathedral and the bronze group of three soldiers at the Vietnam Veterans Memorial are significant additions to the corpus of more than 400 monumental

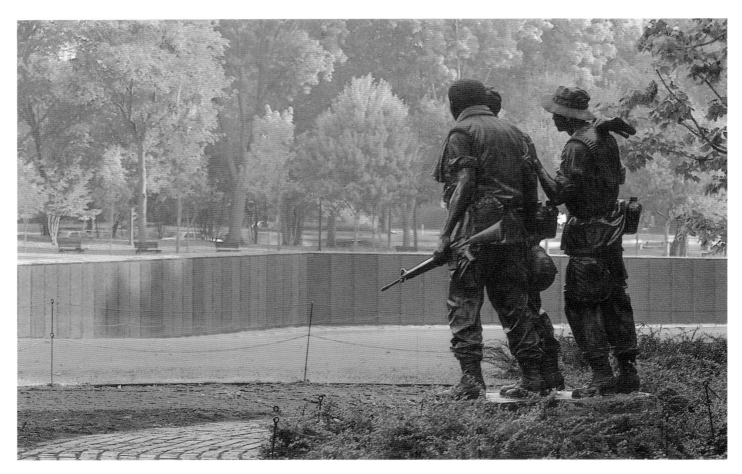

*View of* Three Soldiers *with Maya Lin's wall*

I see the wall as a kind of ocean, a sea of sacrifice that is overwhelming and nearly incomprehensible in its sweep of names. I place these figures upon the shore of that sea, gazing upon it, standing vigil before it, reflecting the human face of it, the human heart.

FREDERICK HART

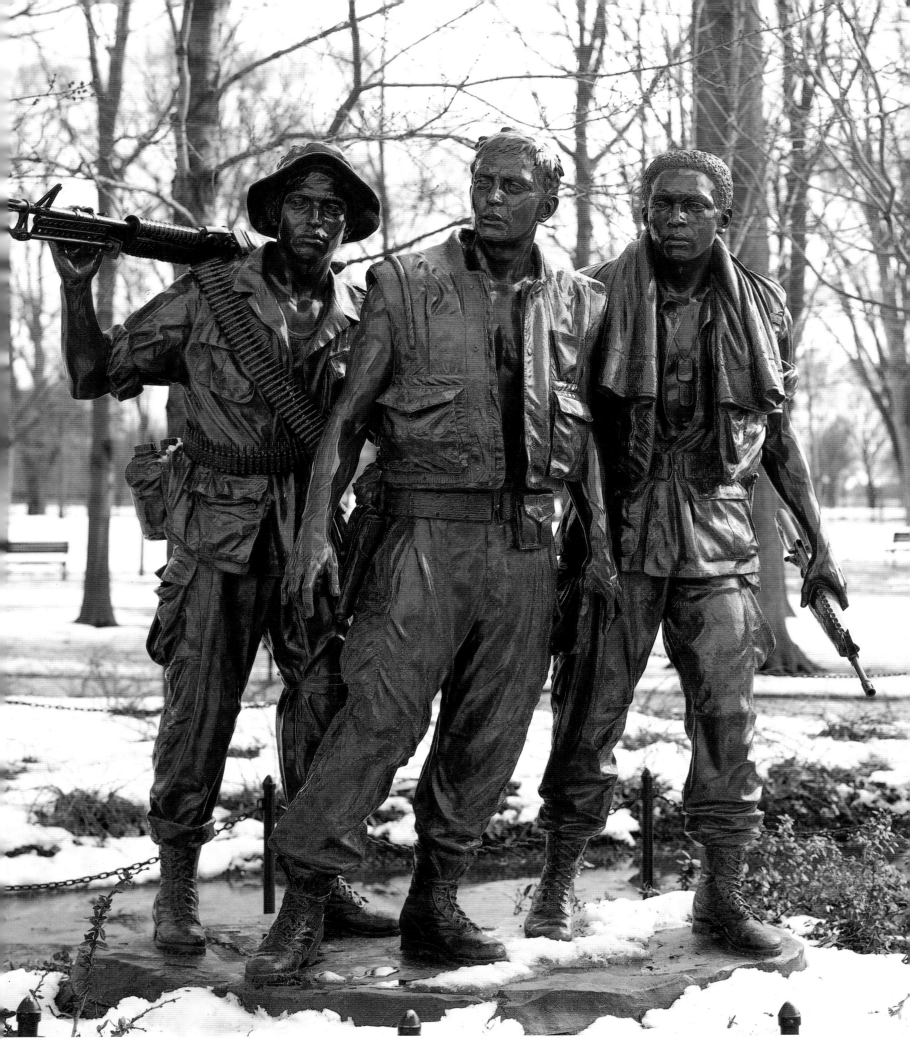

THREE SOLDIERS
52

47

works of public sculpture in Washington. Indeed, Hart's group of three soldiers has already been a leading influence for the return of figurative public sculpture. In the course of only one decade, the three soldiers have become as immediately recognizable as the Iwo Jima Memorial, Mount Rushmore, the Lincoln Memorial, and the Statue of Liberty—all icons of American culture. The widespread recognition and admiration that Hart has achieved stem from his mastery of and adherence to the classical tradition of sculpture—a tradition that he actively upholds and pursues.

*Author's note*
For assistance in the research and editing of this essay, I am indebted to Charles Atherton, Robin de Silva, Stephen Dennis, Richard E. Feller, George Gurney, Susan Kohler, Anne Townsend, and Frank Wright. I am particularly grateful to Homan Potterton for sharing with me his ideas about the classical ideas embodied in Hart's sculpture.

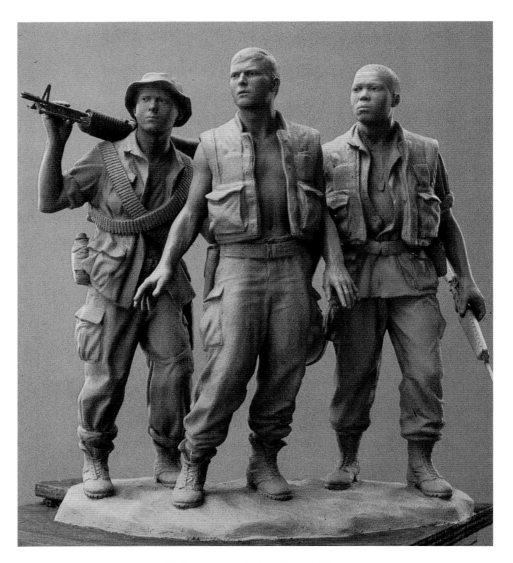

*Preliminary study for* Three Soldiers

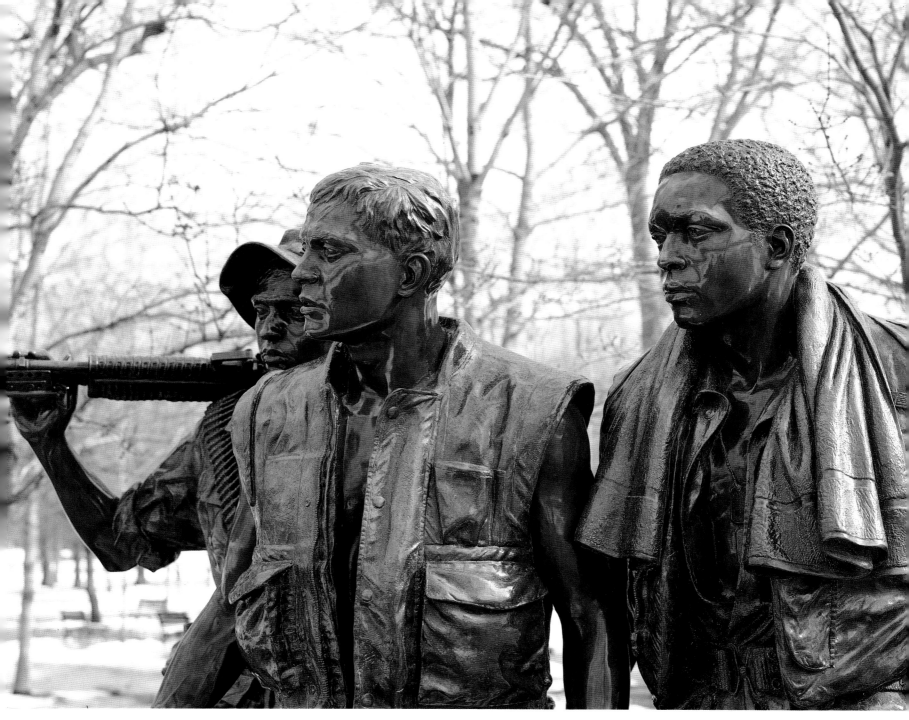

*Detail*, Three Soldiers

49

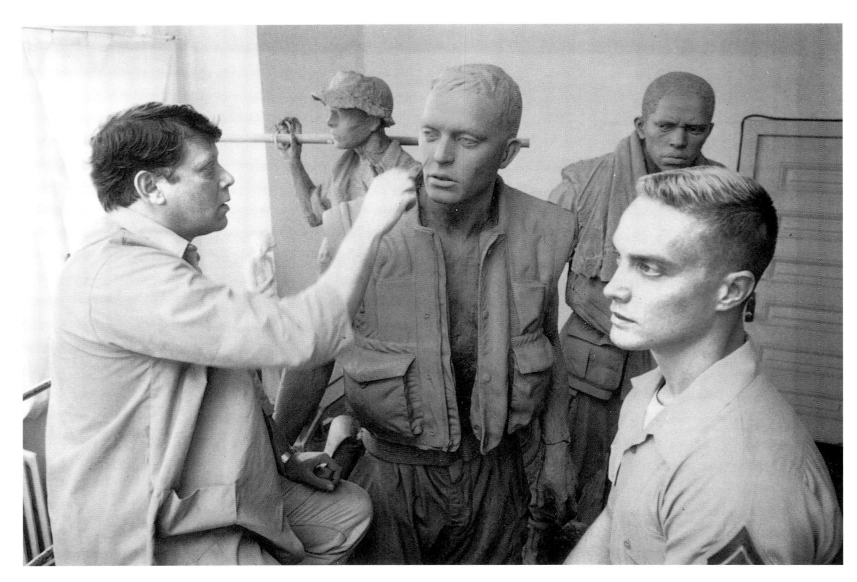

*Cpl. James Connell, USMC, posing for* Three Soldiers

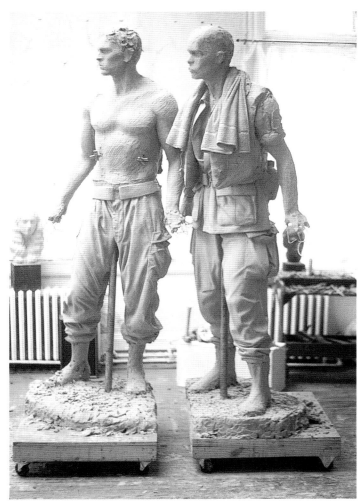

*Full-size figures at mid-point in creation of* Three Soldiers

*Hart putting finishing touches on completed clay model*

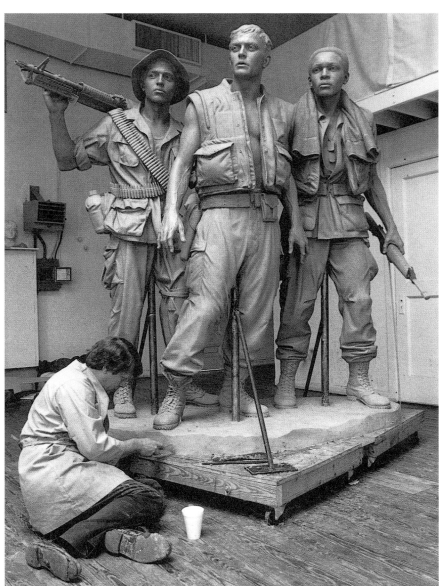

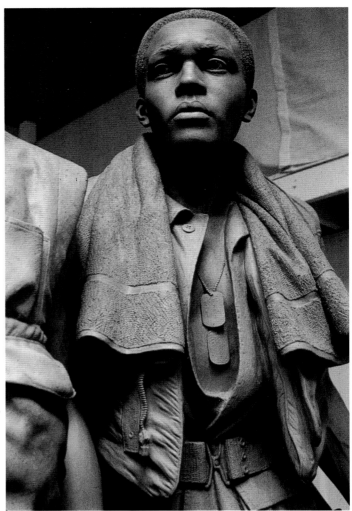

*Details of* Three Soldiers

# A Soldier's Reflections

## FREDERICK DOWNS, JR.

When I look at the Wall—as Maya Lin's polished granite Vietnam Veterans Memorial has come to be known—I know the exact spot where my name could have been, but for the quickness of a Medivac helicopter crew and the supreme skills of a battlefield surgeon. The Wall is abstract, reducing the entirety of the Vietnam War experience to a simple stone slab. I feel relief at my escape.

When I turn and look across the grass, I see Frederick Hart's three bronze soldiers at the tree line. This memorial does not attempt to make abstract what is complex—the experience of combat; the groans, cries, and muttering inside a Quonset hut hospital; our own, and others', brutality; the incomprehensible act of killing; the incomparable horror of watching another human being die. The Wall reminds me that I am one of three million men and women who served in the Vietnam War, who sacrificed, bled, and died because that is what we were asked to do. The bronze figures of Frederick Hart's memorial remind me that I am more than that. They remind me of my humanity.

War is not an abstraction, to me or to anyone touched by its evil. A man killed, a woman widowed, a child orphaned—in Hart's soldiers I see the grief of all of them. I feel their sadness in my heart, and yet I have never been able to express my experience. I only know that it is too powerful to be forgotten. This is why the three bronze soldiers mean so much to me, and to other veterans of the Vietnam War. While many of us suppressed our war memories, relegating them to the area reserved for the imponderables—death, God, the universe—Frederick Hart captured and clarified those memories, creating an icon that speaks to us, and about us.

The three soldiers made of bronze are recognizable. When I look at them, I think: *This is something I understand, those soldiers are me, I am them.* I recognize the looks, the postures. That is what I have been trying, and failing, to describe. I can see in front of me what has been in my mind.

When I look at them, moments of brutality during the war merge with moments of bewildered grief after the war's end. Not a day goes by that I am not reminded of the Vietnam War, and thoughts rush through me like a storm surge. The three soldiers give me a sense of relief and peace. There is some resolution for those undefinable thoughts, for the search for meaning.

Each time I see the three figures, I think, *I am them and they are me.* They will always show the world the way I was at twenty-three. They will be my testament that the war happened. They will portray me for a millennium, long after I have returned to the earth as dust and the war itself is forgotten.

Frederick Downs, Jr. is a Vietnam War veteran and the author of *The Killing Zone, My Life in the Vietnam War*, and other books on the subject.

53

*Hart in front of* Three Soldiers *with men who posed for it.*
*Left to right: William J. Smith-Perez de Leon; Hart; Cpl. James Connell, USMC;*
*Cpl. Terence Greene, USMC.*

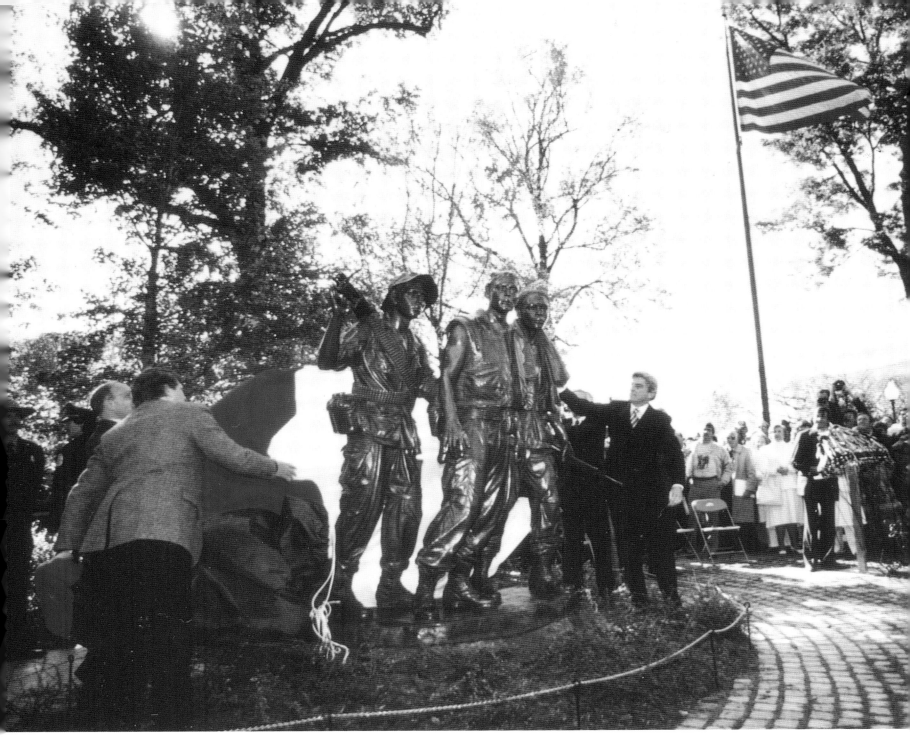

*Unveiling* Three Soldiers

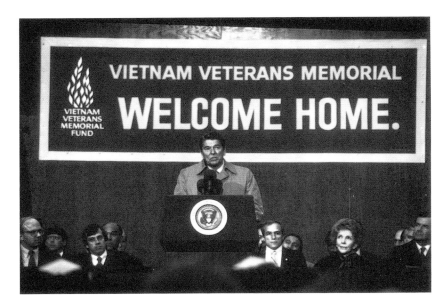

*Dedication day, November 11, 1984*

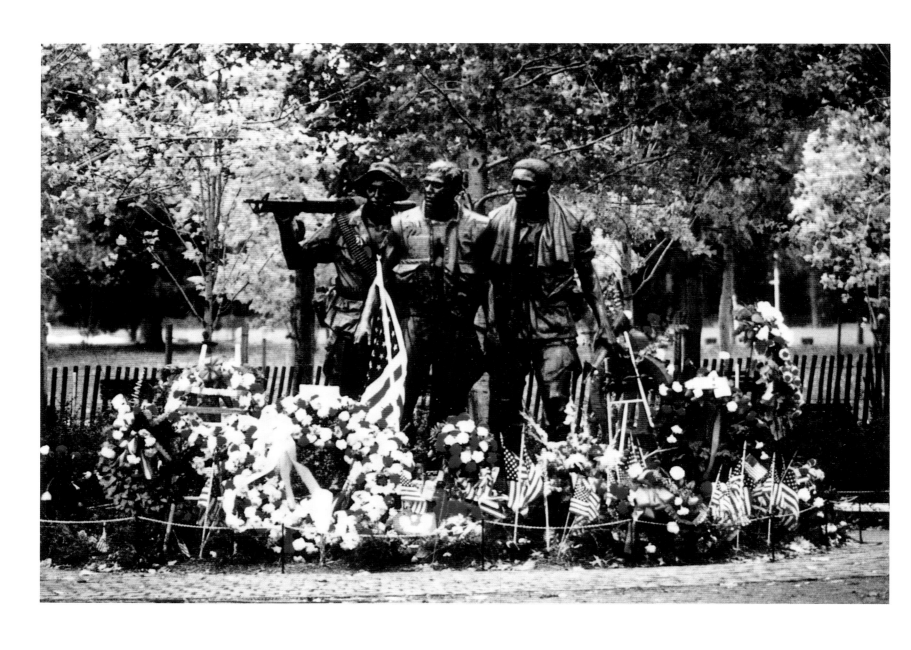

# ESSAYS

# Evolution Out of Chaos:
# The Creation Sculptures

## FREDERICK TURNER

In the thirteen years during which Frederick Hart worked on the Creation series at Washington National Cathedral, he experienced, by his own account, a remarkable transformation of awareness. He read the evolutionary philosophy of Teilhard de Chardin, became a Catholic, and was married. One can imagine the terrifying delight of that time, the time in a major artist's life when he fully discovers his mission, his powers, and the commitments by which he shapes his life and feels the full vertigo of an artist's freedom.

Although this was an important moment in an individual's life, it was an important moment for our culture as well. The very existence of such an artistic genius as Hart, who does not accept the premises of the prevailing artistic culture, signals the end of one era and the beginning of another. The Creation series is modernism's Borodino—that battle in which, as Tolstoy tells it, the Russian army, though defeated, showed Napoleon's Grande Armée that there was a spirit abroad in the world that could vanquish even the spirit of the French Revolution. The Creation works have been studiously ignored by the artistic establishment, which has since found its way into the dead end of postmodernism; but, together with a handful of other works in various art forms by other artists who, like Hart, have felt the change in the world-spirit, they are a silent reminder of another artistic movement whose time is imminent.

Part of the silent power of Hart's work is that it is intellectually more profound than that of his contemporaries. It has often been praised for its romance and passion, but beneath its lush beauty and generous expressiveness is a complex theory of being, becoming, and meaning which is best articulated by the work itself but which can be partly put into words. Consider *Ex Nihilo* (Out of Nothing), a double reference to the standard Latin translation of Aristotle, who maintained, "out of nothing nothing can be made"—and to the Bible, which insists that "everything is made out of nothing". This is a great and ancient paradox. According to the order of linear cause and effect, nothing can come into existence that was not there already, if in another form. Thus art is a product of its social and political context. This is the universe of modern art, where artists must either go along with prevailing trends or rebel against order altogether in hysterical

Frederick Turner, Founders Professor of Arts and Humanities at the University of Texas, Dallas, and former editor of *Kenyon Review*, is the author of *Beauty: The Value of Values*, and *April Wind*, a collection of poetry, as well as many other books on the arts.

acts of random or aleatory self-deconstruction. According to the nonlinear order of chaotic self-organization, new particles can spring out of the quantum vacuum; new, more advanced living species can evolve with characteristics that never existed before; and a new human mind and personality can emerge out of an inchoate mass of fetal cells. A new form is a new substance, and the universe, far from running down deterministically into an eventual heat-death, is evolving and growing into more and more exquisite and beautiful forms of self-actualization. Thus, art is not the follower of political correctness but the medium of a new political morality: the voice of a divine mystery. It is of the order of beauty; and yet its medium—as the sculpture's is of stone and civic will and financial patronage—is of the order of power. The best that power can do is give itself up and over to beauty, as the thermodynamic whirlpool of the base of this sculpture gives itself over to the human forms that emerge from it.

The burden of theological proof has radically shifted in the last two decades. For modernists, that burden was upon those who maintained that a spiritual order lay behind the physical world, because the science of the time seemed to have fairly satisfactorily explained the existence of matter, life, and human society in terms of linear cause and effect, lubricated or retarded by random noise. Things have changed, however. In brain science, the idea of the mind can no longer be avoided—once dismissed by behaviorists and neuroscientists alike, the empirical evidence insists that a top-down causality is at work in the brain, from its highest mental levels to its lowest cellular and atomic ones, as well as the traditional bottom-up causality from atoms to molecules to cells to gross anatomy. In cosmological physics it has become clear that the universe had some sort of beginning, and the best shorthand that serious physicists now use for the fundamental ordering principle of the physical world is "God". In biology and many other disciplines the "strange attractors" of chaos theory suggest that beautiful and unfathomable forms anticipate and govern the most apparently tangled nonlinear processes, and that order underlies chaos. Hart's work reflects this new consciousness, and is thus up-to-date intellectually in a way that cannot be matched by the aleatory or politically determinist works of postmodernism. Once one has studied Hart's sculpture, much contemporary visual art appears dated.

The spiraling forms that recur throughout Hart's *Ex Nihilo* tympanum suggest the spirals that are found in nature—in sunflower heads, nautiluses, hurricanes, and galaxies. The spiral is one of the simplest geometrical forms of self-similarity, that property possessed most conspicuously by the "strange attractors" of chaotic, self-organizing, dynamical systems. The spiral is the classical representation of any feedback process, in which the past and present of that process enter into a nonlinear and unpredictable creative relationship so as to generate its future. The Fibonacci series in mathematics, which generates the Golden Section ratio of classical art, is the numerical equivalent of this spiral: the default option of all growing organisms. The very billows, or flames, or plasma jets, of Hart's sculpture are self-similar in form, like the wave crests of Hokusai's ocean scenes. More remotely, the form of Hart's *Ex Nihilo* also suggests the helix—a spiral is, as it were, a helix seen in perspective down its central axis, and this is a good way to view the whole tympanum. So there is a further allusion to the DNA helix, the basic form of all life on this planet, and the most private bedchamber of sexual reproduction. The sensuality of Hart's figures bears out the progenerative theme.

Pierre Teilhard de Chardin's brilliant synthesis—of evolutionary theory, process-philosophy, and Christian theology—is clearly of central importance in Hart's work: Teilhard plays Aquinas to Hart's Dante. A Jesuit, Teilhard was both silenced and then slowly, partially, and secretly adopted by the Church; his contribution will become apparent in a deepening of Christian thought that will surely occur in the next century. Teilhard believed that the process of biological evolution was only part of a general evolution throughout the universe—of energy into matter, of matter into life, of life into mind—and that this evolution was in fact the actual gestation of God. Eventually the universe would reach the "omega point" at which its divine potential would be fully realized; this would be the millennium of which the Scriptures speak in parable, the kingdom of heaven. The universe would achieve this development with the assistance of the moral efforts of humankind; but humankind could give that assistance only as redeemed by the incarnation of the Word in Jesus Christ, who was an anticipation of the divinity as finally achieved at the omega point. It is this marriage of evolutionary creation, tragic incarnation, and final transfiguration that Hart celebrates in his remarkable Lucite *The Cross of the Millennium*, where the symbols of the Star of Bethlehem, the Crucifixion, and the Resurrection are literally fused within the transparent medium.

Like Teilhard, Hart rejects the modernist opposition of existence and essence (most clearly articulated in existentialism, which asserted the primacy of existence over essence). We may try to translate the eloquence of his stone into the stutter of words in this way: Hart sees the essential as immanent in and unpredictably emergent from the physical world, and sees those essences as themselves the concrete existential womb of new essences to come. It is not only in its intellectual content that Hart's work strikes out in profoundly original directions. In its formal characteristics, his apparently traditional techniques conceal a deeply original conception of representation and signification. Paradoxically, Hart denies his own originality and claims that he is only following the perennial philosophy of classical art. It would take amazing courage for an artist to do even that in a time when the severest pressures for conformity are the rule in the academic and avant-garde art scene. But he is on to bigger game yet: a revision of the idea of meaning that is profoundly new yet that also includes and revitalizes the epistemology of classical art.

The very ambiguity of *Ex Nihilo*'s formal genre—is it a relief or a statue in the round?—as in Jan van Eyck's use of *trompe l'oeil*, says something profound about the nature of meaning and representation. Modernists and postmodernists labor under a conception of reference that is so literalistic and rigid that it is impossible to attain—Jacques Derrida, for instance, insists that since a word is not that to which it refers, the referent of all words is merely absence, and all words are an epitaph for a dead presence. Hart, on the other hand, sees existence as an always coming-to-be, a sudden springing into existence, as Henry David Thoreau put it, and meaning is simply the relationship among the stages of that process. For modernists, time is a linear system of replacement of the past, which must be either countered or accepted by art. For postmodernists time has become completely spacelike—that is, all moments and all histories have become both simultaneous and mutually isolated, since nothing can occupy the same space as anything else. The postmodern world is flat, fragmented, and without history. For the new art of the twenty-first century, of which Hart is a precursor, time is a process of growth and emergence and sub-

sumption; and this conception of time is also a conception of meaning and significance. The bas-relief's signified is the statue, as the statue's signifier is the bas-relief. Thus to call Hart's work "representational" or "realist" simply misses the point.

Hart invites us to reconsider beauty as the true goal of art. Modernists and postmodernists scoffed at beauty, replacing it with a combination of the sublime and the grotesque that would shock the viewer into ideological change. For Hart the descent into the merely sublime is a compromise as shoddy for an artist as the descent into the merely pretty. The sense of beauty is for Hart—as it is for this writer—the recognition of the fundamental creative, self-organizing, evolutionary forces that created and continue to create the universe. And the artist is one who continues and extends that creative process.

If the human body, with its remarkable nervous system, is the most fully developed product of the evolutionary process of which we have knowledge—and it is so, we believe, by any objective measure—it is also, according to this reasoning, capable of the most comprehensive and roundest expression of beauty. Thus Hart's sculpture is humanistic and figural. If beauty is the way we experience the evolutionary process—tragic as it may often be—any art that does not fully embody its historical and cultural past has cut itself off from its own evolutionary roots and is doomed to aesthetic sterility. Thus Hart's sculpture is original partly in and of the very fact that it embraces, subsumes, and builds upon the whole tradition of plastic art.

For Hart, the deepest kind of beauty is moral beauty. He has accepted the severest challenge for any artist: the representation of goodness in a way that is neither bland nor insipid. For writers, the villains are always easiest to create: Shakespeare's evil Iago gets twice the number of lines as his noble Othello; Milton's Satan is more attractive than his God; Dostoyevsky complained that his flawed Ivan was getting more attention from his readers than his saintly Alyosha in *The Brothers Karamazov*. Likewise, for a visual artist it is innocence that is the great test of artistic maturity. Hart's human figures show the mysterious and even terrifying power of radical innocence and goodness: always a little remote from us, they look past us into a light that we cannot see, or, as in the remarkable *Source*, their faces are concealed, because they are not that which we see but the light by which we see it. *The Source*, like the recent French film diptych *Jean de Florette* and *Manon of the Spring*, is a metaphor that celebrates the unblocking of the ancient springs of art and inspiration as personified by the figures. We are, and ought to be, abashed in their presence.

Almost five hundred years ago Michelangelo anticipated the subsequent history of Western art with a series of figures that gradually disappear into stone—figures that demonstrate the tragic reducibility of the human to the material. He thus foretells the breakdown of classical canons, the analysis of perception, the cubist and minimalist reductions, and the final culmination in the abstract. In Hart's *Ex Nihilo* the process reverses itself: out of the seething quantum chaos the figures of the twenty-first century begin to emerge.

# Apotheosis of the Human Figure: An Aesthetic of Evolutionary Humanism

## DONALD MARTIN REYNOLDS

Through the boundless medium of figuration, Frederick Hart explores the primordial and spiritual foundations of humanity, or, as he says, "the concerns of man". In a unique conflation of Yankee Classicism and the Beaux-Arts tradition, Hart celebrates human life through its quintessential form and most enduring symbol—the human figure. From his earliest works to his most recent, Hart focuses on the evolutionary realization of humankind's spiritual potential. His figures are phenomena in the process of evolving, just as the entire universe is one grand process. Moreover, they may be seen as sculptural equivalents to the visionary Jesuit scientist and philosopher Pierre Teilhard de Chardin's global, scientific, and evolutionary humanism, an ideology that helped to shape the fundamental principles of Hart's work.

In none of Hart's sculpture is this idea more profoundly embodied or more movingly expressed than in the *Ex Nihilo* tympanum at Washington National Cathedral, the linchpin of Hart's concept for a monumental sculptural program representing the theme of the Creation. Eight life-size nudes, male and female, twisting and turning, evolve from a chaotic primal mass that fills the lancet of the tympanum, fifteen feet high and twenty-one feet wide. These figures represent a turning point in American art, reintroducing the mystery, beauty, and sense of moral purpose that characterize the great figurative art of the past. Above all, they apotheosize the anatomical integrity and transcendence of the classical nude for the twenty-first century.

While the writhing figures of Hart's *Ex Nihilo* relief may seem to recall Rodin's *Gates of Hell*, they are more closely akin, in their modeling, texture, and composition, to the work of neobaroque and romantic nineteenth-century masters such as Jean-Baptiste Carpeaux, François Rude, and Auguste Préault. In the dynamic sinuosity of the *Ex Nihilo* figures we can also see the influence of the English and American sculptors Alfred Gilbert, Frederic Leighton, Daniel Chester French, and Augustus Saint-Gaudens—all artists whom Hart has long admired. Hart's later works, in particular *Union* (1990), and *Celebration* (1991), seem to have a special affinity with Daniel Chester French's *Memory* (1886), the figure that French called "the greatest effort of my life". Not only is this French's

Donald Martin Reynolds, who teaches in the Department of Art History and Archaeology at Columbia University, is the author of many articles and books on sculpture and architecture, including *Masters of American Sculpture: The Figurative Tradition from the American Renaissance to the Milennium.*

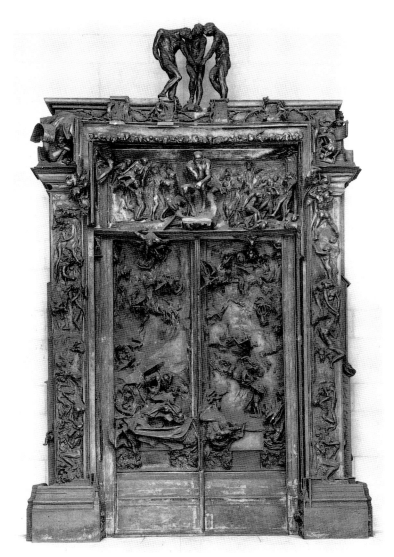

*Rodin,* The Gates of Hell, *bronze H. 250 3/4″ x W. 33*

most beautiful female nude, it is also one of the most exquisite in the whole of American sculpture, celebrating the union of sensual and spiritual beauty. The sinuous line that defines the anatomical sweep from breast to thigh to toe is echoed in Hart's *Torso* (1991), recalling those sensuous *déhanchements* of the mythological figures sculpted by the ancient Greek master Praxiteles. From the dimpling of *Memory*'s right knee to the languorous contours of her right breast and shoulder, as well as her open and vulnerable pose, her mien underscores French's *tour de force* in the blend of sense and spirit, a symbiosis that also informs Hart's figures and that links them to French's best work. As Hart explains, "My works hint at the life essence . . . deep within the sensual form".

The reconciliation of sense and spirit that French achieves in *Memory* and that animates Hart's figures can be traced to the Vermont sculptor Hiram Powers' female nudes of the nineteenth century, such as *The Greek Slave*, works that had a formative influence on French as well as an entire generation of American sculptors, and were the first mature expressions of what I have called Yankee Classicism. That style, which may be best defined as a synthesis of natural and classical forms determined by Yankee principles of craftsmanship and design, opened a new era of naturalism whose repercussions would extend into the twentieth century. Art historian Fred Licht has said, "Powers' concern for a very delicate transcription of the human form animated by a tender silhouette is already remarkably close to the serenity of Maillol".

The parallels between the two sculptors transcend style, sense, and spirit, though. Just as Hart's sculpture has been shaped by the writings of

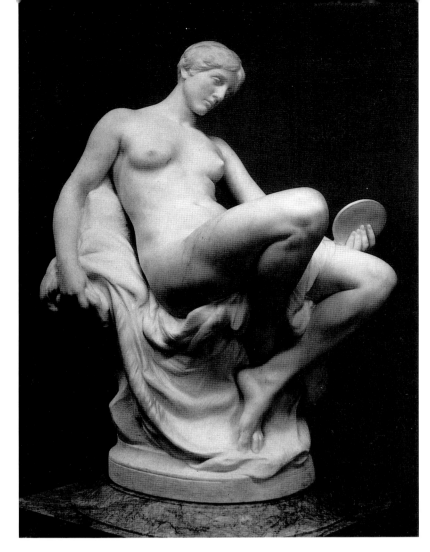

*Daniel Chester French,* Memory, *marble, H. 57" x W. 42" x D. 42"*

*Hiram Powers,* Greek Slave, *marble, H. 44" x W. 14"*

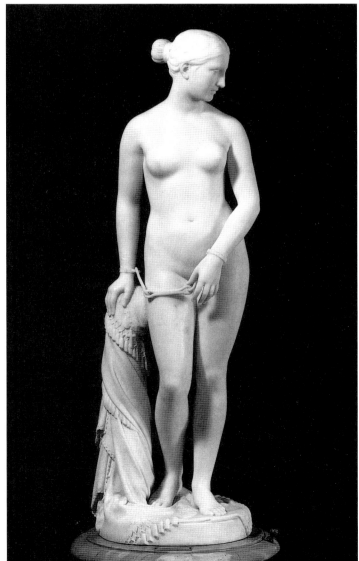

Père Teilhard and by his own beliefs and convictions born of an arduous spiritual odyssey, Hiram Powers' works derived from personal spiritual convictions as well as from the writings of a contemporary divine, Emanuel Swedenborg, the eighteenth-century Swedish scientist-turned-mystic.

Swedenborg, whose influence extended to both American and European sculptors, taught that at death we shed our earthly body and exist in a spiritual one, through which our soul shines, as if unveiled. Powers saw the ideal nude statue as an "unveiled soul", the sculptural equivalent to Swedenborg's spiritual body. He wrote in 1853 to his friend and fellow expatriate Elizabeth Barrett Browning, "the legitimate aim of art should be spiritual and not animal" and "the nude statue should be an unveiled soul". Powers' words corroborate Kenneth Clark's characteristically insightful observation of spirituality's primacy in art, which J. Carter Brown recalls in analyzing the "spiritual effectiveness" of Hart's sculpture (see the introduction to this volume).

Not only are Frederick Hart's figures descendants of Hiram Powers' "unveiled soul" in their conflation of sense and spirit, Hart's ingenuity and inventiveness in his working methods also link him to the nineteenth-century master. Hiram Powers was the son of a Vermont farmer who "valued himself on the curve of his ox bows and yokes" and who boasted that he could "strike with the blacksmith". Powers inherited his father's mechanical aptitude, and, as a sculptor, developed new tools and techniques for working with clay and in finishing marble, as well as a revolutionary method of modeling and carving in plaster, long before the advent of direct carving. Very few people realize that it was Hiram Powers who invented the open file, a tool still in universal use by sculptors today.

Further, Powers rediscovered the Italian marble quarries at the foot of Monte Altissimo, near Pietrasanta (where the Serra and Vezza rivers come together), which were opened by Michelangelo for the great family of patrons, the Medici, in the early sixteenth century. Powers considered Serravezza marble, as it was therefore called, flawless and its porosity and color close to that of human flesh. Thus it was the ideal material when naturalism was the goal.

Hart, like Powers, stepped off the beaten path in pioneering new methods to create an art with "a majestic presence" and "to explore the subtleties of the human soul". For example, Hart uses a method he patented in 1982 to embed one or more forms cast from clear acrylic resin inside another, creating hologram-like images in which beauty and truth are fused through what Hart calls "the twentieth-century looking glass of Lucite". With this new medium, Hart explores "the relationship of light to surface as it is both absorbed and reflected, actually becoming an integral part of the finished work".

In Hart's Age of Light collection of twelve limited editions (1984–1990), each sculpture is an outgrowth of the "search for the spiritual" that the artist first explored in the Creation program at Washington National Cathedral. Moreover, Hart articulates both the evolutionary and the biblical traditions of creation, in two major works. Humanity emerges through the celestial ether in *Breath of Life* (1990), and *Eve* (1991) is at one time the recipient and the source of the divine gift of life. In pairing recumbent and transcendent images, Hart unveils the sensual and spiritual duality of the female nude in *Echo of Silence* (1992), and celebrates the human odyssey toward self-realization in *Dreamers* (1993). His *The Cross of the Millennium* (1992), captures the birth, death, and resurrection of Christ, and celebrates the approaching year 2000. Because the redemption embodies timeless values

common to all mankind, the cross transcends denominational boundaries and becomes a universal symbol of brotherhood.

The masters of the late nineteenth and early twentieth centuries who influenced Hart's sculpture were for the most part products of the European academic tradition, sculptors who either studied at the Ecole des Beaux-Arts in Paris or learned from those who did. Beaux-Arts models and principles were drawn from ancient, Renaissance, mannerist, and baroque art, rooted in man's earliest artistic expressions of the human figure, whose origins are found at the dawn of humanity. Beaux-Arts sculptors modeled their figures in clay, then cast them in plaster and subsequently in bronze, or transferred their dimensions to stone by means of a pointing device. The system, involved a body of artisans who made the molds and did the casting, pointing, and carving.

The trend toward direct carving in the United States in the second decade of the twentieth century eventually destroyed the Beaux-Arts studio system and even though it opened up new avenues of sculptural expression, it also drove a wedge between the human figure and figurative sculpture. By the 1930s, open-form metalwork contributed to the divorce. Then sculptors casting figures from life, often fully clothed, further rejected anatomical integrity and the classical nude, which had been the linchpin of the figurative tradition since antiquity. Meanwhile, a growing contingent of modelers and carvers remained faithful to the anatomically conceived figure, and they continue today to perpetuate that venerable tradition, which coexists with what figurative sculptor Richard McDermott Miller has called the "apparently irreconcilable artistic impulses of abstract art"—underscoring "apparently". He believes the Vietnam Veterans Memorial—Maya Ying Lin's polished black granite wall and Frederick Hart's realistic servicemen—best illustrates the compatibility of abstraction and realism.

Hart perceives the juxtaposition of the two works as a total concept. "I see the wall as a kind of ocean, a sea of sacrifice that is overwhelming and nearly incomprehensible in its sweep of names. I place these figures upon the shore of that sea, gazing upon it, standing vigil before it, reflecting the human face of it, the human heart." J. Carter Brown sees Hart's three soldiers as a "kind of Greek chorus facing the wall, commenting on its meaning". The National Geographic Society expressed the profound need that the nation feels for such memorials: "the sons and daughters of men killed in Vietnam will look up at the sculpture and say, 'This is my father; I never saw him alive. But he wore those clothes. He carried that weapon. He was young. I see now, and I know him better'".

Frederick Hart decries the modernist dictum "art for art's sake", which, he argues, has produced a century of nihilism. "If art is to flourish in the twenty-first century", he insists, "it must renew its moral authority . . . by rededicating itself to life . . . and must pursue something higher than itself". Hart therefore calls for a return to the ancient criteria of truth, beauty, and goodness. In other words, in its mastery of form, art must grab us by the heart, the mind, and the soul, and must embody humanity's highest values and celebrate society's noblest aspirations.

# The Reënchantment of
# Public Art

## JAMES F. COOPER

The end of the last century brought with it widespread feelings that some-thing new was coming. A *fin de siècle* often arouses trepidation and excitement, and the start of the twentieth century was particularly laden with political, economic, and cultural omens. New ideas and ideologies threatened the old order, and the most prescient and talented were launch-ing an attack on the revered traditions of Judeo-Christian/Greco-Roman civilization. Picasso's *Les Demoiselles d'Avignon*, Stravinsky's *Rite of Spring,* and James Joyce's *Ulysses* signaled the arrival of a particularly vio-lent and chaotic century.

Now a new century approaches, bearing the added weight of a new mil-lennium. The coming cultural changes are at least as profound as those posed by the start of the twentieth century. This vast sweep of history's pendulum will result not in small changes of style (such as the postmod-ernist shift) but in a new paradigm, a realignment of human activity and thought. When new ideas occur, people resist the change vigorously: it upsets the order achieved by institutions and traditions. It redistributes knowledge, wealth, and power. It changes the way we comprehend the world around us.

The next century, too, will be defined by artists and writers possessed of extraordinary vision. Like the early modernists, they will be initially rejected because they threaten established thought. If twentieth-century culture is about deconstruction, with every value and criterion perceived as relative and contestable, the new art may be based on alternative crite-ria of beauty and transcendence. After a century marked by unprecedent-ed savagery and nihilism, shaped by Marxism and modernism, we yearn for freedom and harmony. Those who challenge the prevailing order risk being ostracized. Only artists with extraordinary gifts, vision, and charac-ter will be able to break through the bureaucracy that imprisons the cul-ture. Frederick Hart is such an artist.

I became convinced that Frederick Hart possessed the talent (and, indeed, had already created a seminal work of the new era) when I visited Washington in 1989. I did not know Hart then, although I was familiar with his *Three Soldiers* for the Vietnam Veterans War Memorial. In 1982 I attended the Commission of Fine Arts' hearings on the installation of

James F. Cooper, founding Director of Cultural Studies at the Newington-Cropsey Foundation in Hastings, New York, writes and lectures on contemporary American art and culture.

Hart's controversial figurative work on the Mall in Washington, as a counterbalance to Maya Ying Lin's minimalist wall, which would be the focus of media attention for some time. On Veterans Day newspapers and television screens were filled with scenes of weeping veterans and widows, making rubbings from the names engraved on the wall and laying flowers and other memorabilia, which would be gathered and stored in a newly formed museum. During all that time, however, Hart's *Three Soldiers* was rarely mentioned. In print it was referred to as "the other memorial".

A curtain of critical silence descended over Hart's work. In 1989, when a letter by the sculptor was published in the *Washington Post*, the curtain lifted briefly to allow a barrage of critical attacks. "Works of art", Hart wrote, "achieve greatness by embodying great ideas, as well as by sheer mastery of the medium". He called for a turning away from destructive cultural self-indulgence and for a rededication to artistic excellence. The letter was so provocative, intelligent, and courageous in defining issues of public art and government sponsorship that I telephoned the artist for an interview. I didn't dream my trip would prove to be a personal epiphany; I had almost given up on finding a contemporary artist whose work could be measured against the Old Masters.

During the first minutes of our interview, Hart casually asked if I was familiar with his Creation sculptures at Washington National Cathedral. I wasn't. With the exception of a brief article in *National Geographic* (1980), almost nothing has been written about this monumental work, which occupied the artist's energies for more than twenty years. Within minutes we were standing in front of the great cathedral, conceived originally by George Washington. It took eighty-three years to build, after the cornerstone was laid in 1907. A scaffold was braced against the front entrance to allow the stone carvers to make last-minute preparations for the official unveiling of the sculpture, preceding by a year the official dedication of the National Cathedral. Then, almost on cue, they climbed down from their perch, giving us a clear view of the work as we mounted the steps at the base of the western facade. The setting sun illuminated with breathtaking clarity the details of one of the most beautiful works of art I have ever encountered.

As I gazed dumbfounded at the eleven carved figures above me, I realized we were alone. No crowds gathered in front of the cathedral to celebrate this wonderful event. Then I realized that the man standing beside me, singlehandedly, beginning at age twenty-six in 1969, had conceived and brought to fruition a work of art that successfully challenges the combined artistic vision of the last half century.

At certain moments in history—when Braque entered Picasso's studio and confronted *Les Demoiselles d'Avignon*, when Joshua Reynolds confronted David's *Oath of the Horatii*—one encounters a work of art that possesses the aesthetic, contextual, and moral strength to signal the start of a new era. The Creation sculptures is such a work. Within its forms lie the imagery and beauty to spark an American renaissance.

Sheldon Cheney remarks that it takes thirty years—one generation—before the public catches up with a great artist. We have only a few more years to wait before the American people and the art world understand what has been wrought here. Until then, it is appropriate that this great work adorns the facade of the structure chartered by Congress for the express purpose of promoting national education, character, and spiritual values.

Three massive stone bas-reliefs, carved from Indiana limestone, are set

in the tympana above the cathedral's great bronze doors. Life-size carved figures of Saint Peter, Saint Paul, and Adam flank the entrance portals. The largest bas-relief, *Ex Nihilo*, consists of eight life-size figures emerging from a twenty-one by fifteen foot "primordial cloud" with all the tender power of Michelangelo. In *Ex Nihilo* the "empty" space of the composition takes on added significance because it represents the void God transforms into matter; its swirling spirals become the substance that binds the elements of creation together.

The three figures of Peter, Paul, and Adam are distinctly American in their expression of innocence, eyes closed as if emerging from a dream. Adam, portrayed in the act of freeing himself from his delicately wrought stone embryo, lifts his rapturous face toward heaven as if still in silent communion with his maker. The eight virginal souls emerging "out of nothingness" do not have the suffering, prescient faces of Michelangelo's figures, twisted with torturous self-knowledge. Rather, they are individuals in the act of "becoming", before self-realization, even as we Americans are caught up in the process of "becoming", defining ourselves as a people.

This same innocence extends to the three soldiers, who seem, despite their uniforms and weaponry, vulnerable and apprehensive. The iconography does not reflect the certainty and unexamined heroism of earlier war memorials, but becomes a metaphor for an America uncertain about its values. Still, Hart's refined sense of form, balance, and detail underscores the perception that, even if his figures do not recognize order and harmony, we do.

Hart's fusion of the formal and contextual reestablishes a standard of artistic excellence in public art rarely seen since the days of Augustus Saint-Gaudens and Daniel Chester French. Indeed, French's *Samuel F. DuPont Memorial*, located near Hart's original studio off DuPont Circle, inspired Hart during the three years he wrestled with the models for the Creation sculptures. Hart's uncompromising commitment to beauty and form separates his work from that of his contemporaries.

Even those who admire the realism of his sculptures are sometimes not aware of their formal, aesthetic qualities. These qualities give a work of art —Athenian, Renaissance, or impressionist, Assyrian, Nigerian, or Kwakiutl —its timeless quality. The seminal work of modernism, Manet's *Le Déjeuner sur l'Herbe* (1863), succeeds precisely because it "works" on two levels: aesthetically and contextually. Nineteenth-century critics shortsightedly focused their attacks on its anti-Salon iconography, but it would take several decades before the public (and critics) realized its more important innovation: an aesthetic radically different from and superior to that practiced by the pompier academicians.

Within the seemingly innocent still-life of basket, fruit, and luncheon accoutrements, exquisitely composed in the lower left corner of *Le Déjeuner sur l'Herbe*, on the grass just below the naked buttocks of the young women smiling "shamelessly" out toward the viewer, lies the real and very potent DNA of modernism. The painterliness and flatness, the color, the linear and formal abstraction of this detail would evolve with lethal intensity into fauvism and cubism. The "lewdness" of nude girls juxtaposed with fully clothed modern young Frenchmen is of little consequence when compared to the powerful juxtaposition of colors and forms in a basket of fruit. Linda Nochlin praises the modernism of "*Déjeuner*, in its ambiguous iconography . . . its lack of nuanced modeling, the starkness of the separate color areas and the schematic reduction of the nude . . . the

shadows have begun to assume an independent formal identity, the spaces between the figures to play a role of their own, the faces to assume that iconic remoteness so characteristic of modern art".

Aesthetics was still a criterion for modernism until the second half of the twentieth century. Matisse "dreamed of an art of balance, purity and serenity . . . . Only plastic form has true value", he wrote. "A work of art must carry within itself its complete significance and impose that upon the beholder before he recognizes the subject matter. When I see the Giotto frescoes at Padua I do not trouble myself to recognize which scene of the life of Christ I have before me, but I immediately understand the sentiment which emerges from it, for it is in the lines, the composition, the color. The title will only serve to confirm my impression" (*Notes of a Painter*). The harmony, beauty, and transcendence of Hart's Creation sculptures are apparent from a distance, even before one is conscious of the details.

Such qualities are no longer considered relevant. Imagine trying to describe the nature of modern art to an 1860s audience familiar only with the pompier style. Imagine trying to describe the philosophical and aesthetic raison d'être of Edouard Manet's *Déjeuner* to a nineteenth-century audience weaned on the ubiquitous licked-surface canvases of the Salon and accustomed to subjects such as *The Birth of Venus* (1862) by Alexander Cabanel and *Zenobia Found by the Shepherds* (1850) by William Adolpho Bouguereau.

Who in 1863 could anticipate the works of Vincent van Gogh and Paul Gauguin, of Cézanne, Matisse, and the fauves, or, a decade later, of Picasso and the cubists? Certainly not the learned peer-panel judges who rejected *Déjeuner* for the Salon of 1863. As late as 1890 (the year that had already witnessed the deaths of Courbet, van Gogh, and Manet) Cabanel's *Birth of Venus* (on display at the Paris Exposition) was still being proclaimed by members of the Academy and Salon as the "greatest painting of the century".

Within the delicately turned forms and exquisitely chiseled features of Hart's Creation sculptures is the DNA of a new movement, as yet unnamed. Hart's work is about transcendence and renewal. Like Manet, the sculptor employs the highest aesthetic standards. Hart restores American art to the mainstream of world culture, reconnecting public art to great ideas. It answers the longing of the American people for a new vision. "Once, art served society rather than biting at its heels", Hart explains. "Once, under the banner of beauty and order, art was a rich and meaningful embellishment of life, embracing—not desecrating—its ideals, its aspirations and values."

Hart's public sculpture art testifies that we are a great people, a spiritual people, yearning for new directions, filled with a longing for beauty and transcendence. We owe much to this artist who refused to offer a shattered mirror reflecting only the mundane ugliness and chaos of contemporary life. Instead, like great artists of the past, he looked inward for inspiration. His years as an apprentice stone carver within the great cathedral honed him spiritually for his great task. Returning to the timeless values that spin through human history like a golden thread, Hart offers us a way to pull ourselves out of the chaos we have unthinkingly allowed ourselves to slip into.

Like Manet's *Déjeuner sur l'Herbe*, the Creation sculptures will be misunderstood. Many will embrace or reject this work because of its strong spiritual content, but its formal aesthetic qualities carry an even greater message. "The Creation sculptures are about form, beauty", explains the sculp-

tor. "In today's art world, I am a total outsider, because to accept me is to reject a lot of modern dogma about art. My work is an anachronism, because it strives for substance and beauty . . . Realist artists today have forgotten how to address the larger issues of beauty, truth, God, good and evil."

Frederick Turner suggests that beauty is the cognitive tool by which we define and recognize reality. If we accept that premise, then beauty is critical not only to the arts, but also to the very survival of the human species. Some critics dismiss Hart's work as grandiose. But, as John Boardman writes in a discussion of Greek sculpture, without an appreciation of its "artistic quality", we would be forced to "dismiss the Parthenon as a gaudy and extravagant display . . . of propaganda, politics and religion . . . by a hubristic city council".

The Creation sculptures represent a paradigm of enormous consequence. Hart has appeared at the very moment when we as a nation need a vision to inspire us to move forward into a new century. Against all odds, a young man, a veritable David, has arrived to slay doubt and confusion. He has created a seminal work, a new heroic vision of men and women together. The work's extraordinary beauty is very much a part of its message. It is fitting that this great work of art graces the facade of what Pierre L'Enfant, George Washington's architectural planner for the City of Washington, called "a great church for national purposes".

# Transcending Tradition:
# The Cast Acrylic Resin Works

## ROBERT CHASE

When talking about the process of making sculpture, Frederick Hart often repeats the saying "The clay is the life, plaster the death, and stone the resurrection." It is not surprising that Hart might speak in such metaphors. Religion informs his art, isolating him from most other contemporary artists and at the same time meeting an apparent need for art that is spiritual and humanist in inspiration, and marked by the aesthetics and processes of tradition.

Driven by an impulse to convey the idea of transcendence—physical but above all spiritual—in the course of his career Hart has progressed from making architectural ornaments, to stone carving, to conceiving and masterminding monumental public commissions carved from stone and cast in bronze. While an undergraduate student, he immersed himself in the writings of Père Teilhard de Chardin, and emerged with the idea of giving concrete form to Teilhard's vision of the Creation. The theme became almost an obsession, and served as a point of reference and departure. A technological turning point in Hart's career came in the 1970s, when he first tried to cast clear acrylic resin.

In the subsequent works, achieved only after more than a decade of experimentation, frustration, and perseverance, his art would find another level of expression and a new, almost literal interpretation of the theme that had occupied him for so many years. Forms—themselves symbols of consciousness—would emerge from, and into, the nothingness of the crystal-clear, yet curiously "warm", medium. The new material would make possible a perfect realization of the idea he first explored in 1971, when he sketched two works in clay: a child coming into being inside a rough-hewn womb, *The Child*, and an inner image reflecting the inner self, emerging from within another form, *Herself* (see following page).

THE CHILD
26

Robert Chase is a founding partner of Sculpture Group Limited, governing member of the Art Institute of Chicago, lecturer, and collector.

73

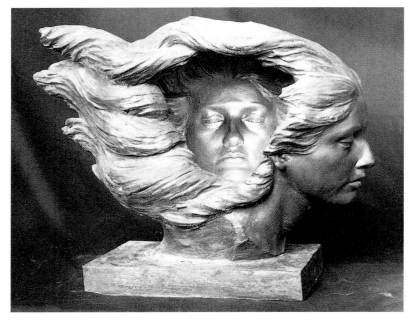

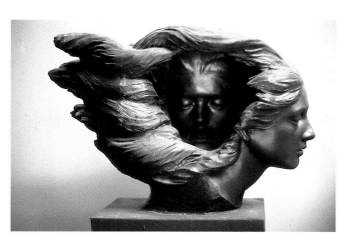

HERSELF
*(bronze:1979)*
50

*Clay model for* HERSELF *bronze:* 1971

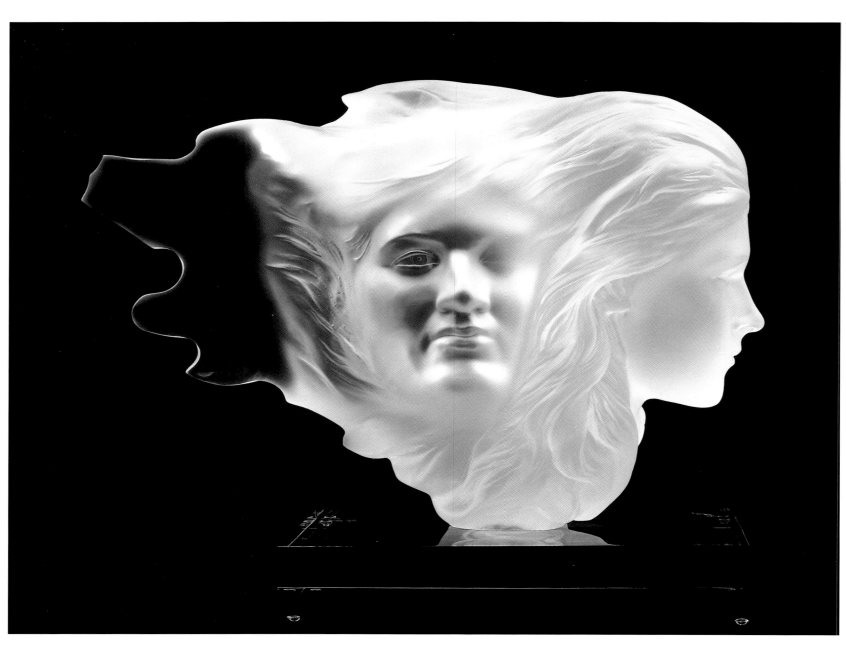

HERSELF
*(clear acrylic resin:1984)*
51

Although artists have been casting bronze and other metals since antiquity, no legacy of casting clear acrylic resin existed when Hart first determined to master the new medium. It had been used before, for abstract assemblages (because it could be cast in geometric forms using a rigid mold) as well as for nonaesthetic and industrial purposes. Until Hart, however, no sculptor had harnessed its potential as a medium for cast figurative sculpture that required undercuts as well as flexible molds.

Hart's success did not come immediately. He first had to resolve the problem of finding a suitable material from which to make a flexible mold that did not dissolve or break down when it came into contact with the monomer in the acrylic, and that would allow him to cast figurative forms in one piece. Second, he had to perfect his "embedment" process, which was plagued with recurring difficulties that made it impossible to achieve a proper and consistent translucency for the interior sculpture. The solutions to these problems were original to Hart. In 1982 he was granted a patent for the embedment process, marking the end of a decade of experimentation and the progression to another decade of refinement.

In the same year, as he was bringing his work at Washington National Cathedral to its conclusion, Hart cast *Gerontion* (see page 120)—a reference to the poem by T. S. Eliot of the same title—and in 1983 he cast two figures collectively titled Sacred Mysteries: Acts of Light. Following fast on the heels of the cathedral works, in which figures emerge from a chaotic mass of stone, these figures represent an aesthetic and attitudinal change, emerging now from light—and disappearing into light as well. From this

SACRED MYSTERIES: ACTS OF LIGHT: *Female*
44

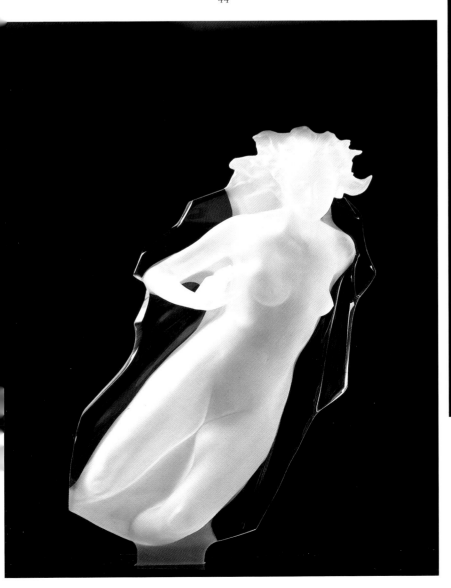

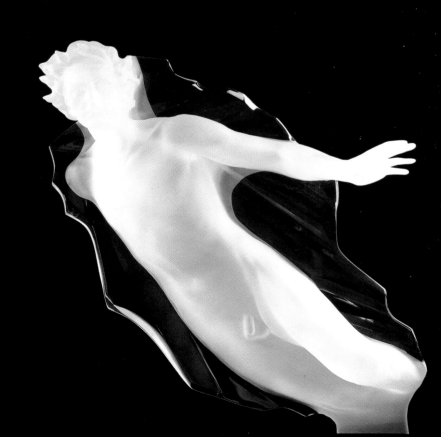

SACRED MYSTERIES: ACTS OF LIGHT: *Male*
45

point on, Hart began to equate light with life and spirit, thus the medium itself conveyed meaning, beyond the iconic, representational, or figurative aspects of his art. *Herself* was the first in the Age of Light, a series of twelve editioned works in clear acrylic resin. Three "embedded" works within that collection—*Memoir* (1985), *Spirita* (1988), and *The Ride* (1990) (see page 91)—followed, bringing Hart's vision full circle. The "embedded" works are multidimensional, twentieth-century variations on a pictorial device used by the Renaissance masters, who painted finely detailed narratives of such themes as the Life of Christ, in which events unfold at different points during the viewer's experience of the work.

By the late 1980s Hart had completed the Age of Light collection and embarked on the Creation series, his second editioned collection, which both echoed and developed selected ideas from the sculptural program of the same title that he had conceived in stone for the main entrance on the west facade of Washington National Cathedral. This second editioned collection comprised eight works, four bronzes and four embedded clear acrylic resins. These are distinguished by an increasingly allusive rather than representational nature. By 1992 Hart had begun another collection, Dreams: Visions and Visitations, in which he attained a new level of subtlety in manipulating the medium and depicting the undeniable existence of two levels of being, the physical and the spiritual. *Echo of Silence* (1992) (see page 93), in which this vision was literally unveiled, was Hart's first mixed-media cast acrylic resin sculpture, introducing mica and other materials into the casting and finishing process. *The Cross of the Millennium* (1992) (see pages 108 and 109), his most ambitious work to date in this medium, simultaneously represents the birth, death, and resurrection of Christ. While most of the works mentioned above are relatively small in scale and made for private collectors, Hart has also explored

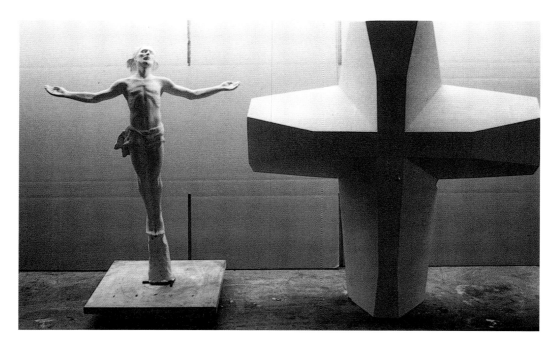

*Maquette for* The Cross of the Millennium

76

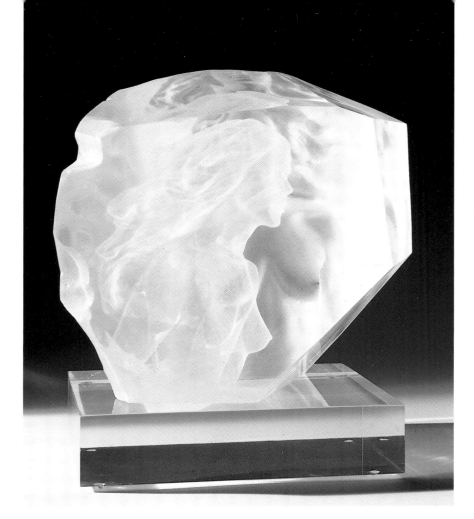

MEMOIR
55

SPIRITA
64

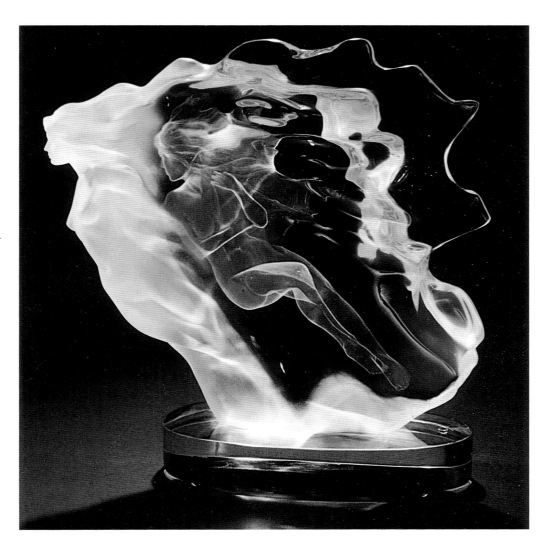

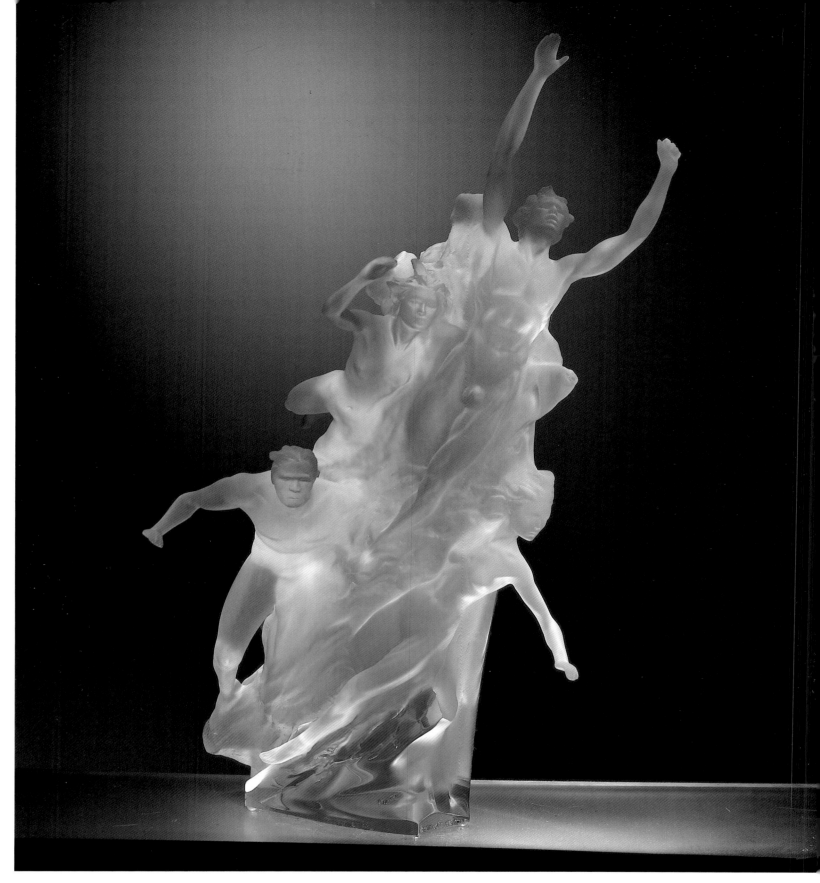

HEROIC SPIRIT
86

the potential of the new medium for casting monumental public sculpture. He has completed the models for a proposed sixteen-foot-high monument entitled *The Heroic Spirit*. The monument would commemorate the hundredth anniversary of the modern Olympic Games, which will be officially celebrated in Atlanta, Georgia, Hart's birthplace. Dedicated to the heroic spirit of mankind personified by the Olympic athletes, the work is intended to be set in a fountain plaza, and would be inscribed in gold, silver, and bronze with the names of all the nation's Olympic medalists.

Hart believes that sculpture created from materials not available to earlier artists, such as clear acrylic resin, will eventually achieve the stature of stone and bronze—the materials used for monumental sculpture through the ages—just as he believes that a new aesthetic, informed by spiritual and humanist ideals, will gain momentum and ultimately prevail in the new millennium. The works cast in clear acrylic resin are at once the most highly evolved expressions of Hart's artistic philosophy and the precursors of that new aesthetic.

## TECHNIQUE

Hart begins the process of creating a sculpture cast in clear acrylic resin, or Lucite (DuPont's registered trademark for the material), the same way that he would begin a work in bronze or stone: by sculpting it in clay, often working from a live model. The conceptual phase takes many months. The artist works through ideas with numerous clay sketches before he proceeds to create a full-size model in clay. Only after this point does the production of each sculpture begin, under his direct supervision. The production of each piece in the edition takes two to three weeks.

*The author and Hart with clay model of* Sacred Mysteries: Acts of Light: *Female, 1979*

*Hart examining acrylic* Herself *at foundry with (left) Ovidiu Colea and (center) Rami Ron*

The clay model is cast in plaster, which is then finished. A flexible mold is made from the plaster cast—often four or five molds are necessary.

A liquid monomer, or binding medium supplied in powder form, and a plastic resin polymer are mixed to achieve the consistency of syrup, and poured into the mold.

The material sets; after about eight hours the mixture begins to gel and take the form of the mold.

The mold is placed in an autoclave and "polymerized", that is, heated to 200-250 F°, under sixty-five to seventy pounds of pressure per square inch, for fifteen hours.

The mold containing the sculpture is gradually cooled over a period of ten to fifteen hours. The mold is removed from the autoclave, and after final cooling it is opened and the sculpture is removed.

The "frosted" exterior skin is sanded with many grades of sandpaper, then buffed and polished. Certain areas are then frosted or abraded with sand to differentiate the translucent and transparent areas and to achieve the desired optical effects.

It is only at this point that the artist can determine if he has achieved success. He may reject a sculpture, or wholly rework it. Or unanticipated optical effects may enhance the work beyond his expectations. Unlike the opaque materials of clay, stone, and bronze, clear acrylic resin is unpredictable; light passes through it rather than bounces off it. Thus it is impossible to know if a sculpture expresses what the artist intended until it is cast and finished.

The success in the acrylic works is owed not only to Hart's imagination but to his collaboration with the highly accomplished caster and resin technician Ovidiu Colea.

# PLATES

VISITATION
67

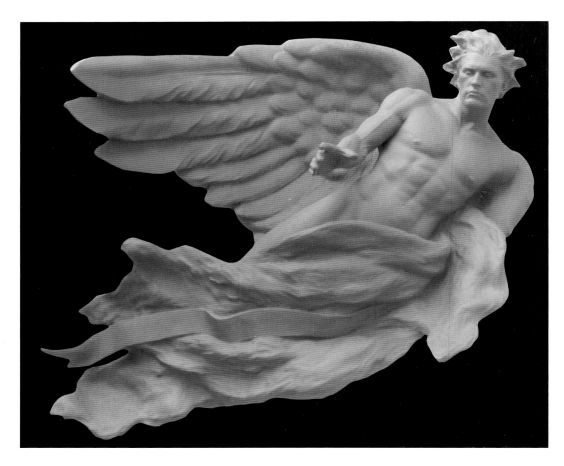

*Clay model of* THE HERALD

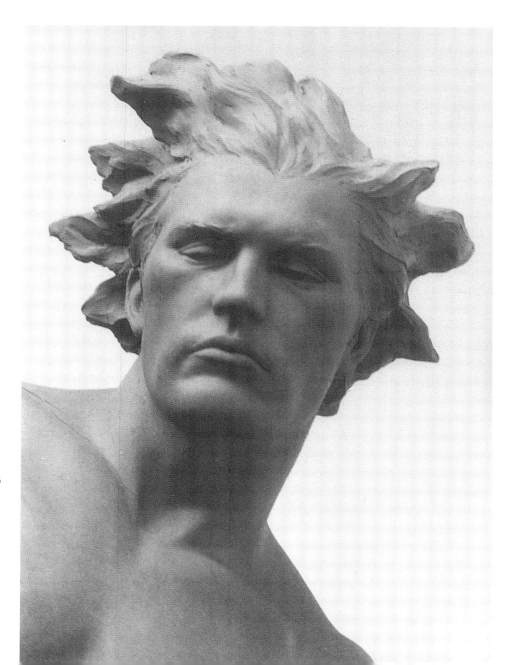

*Detail of* THE HERALD

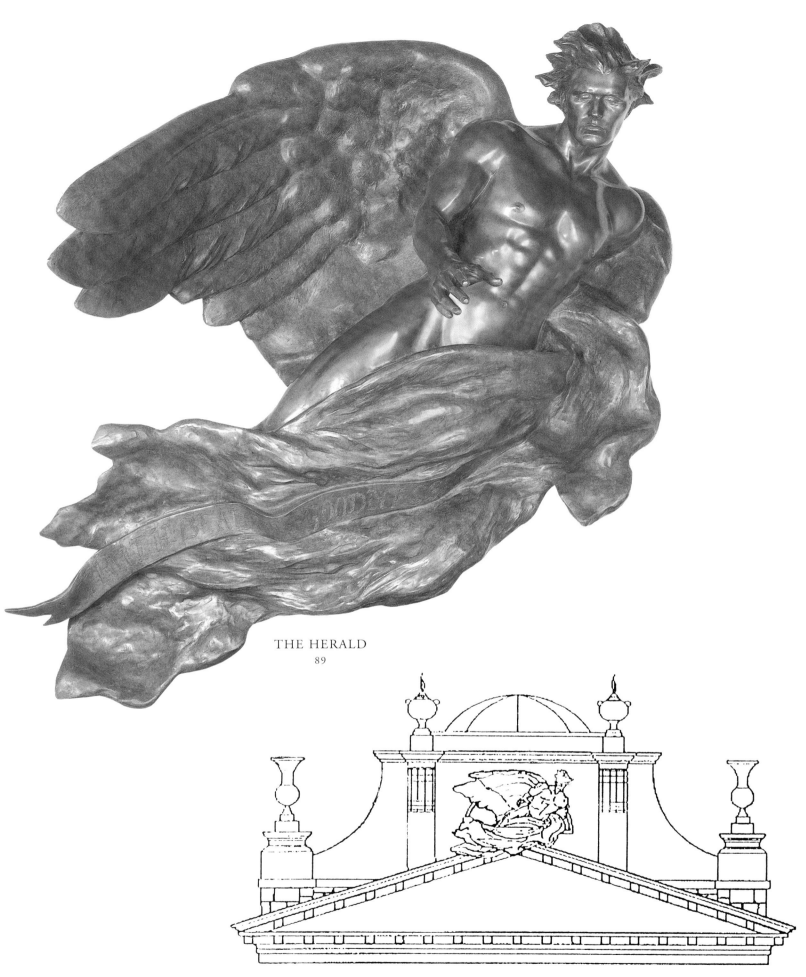

THE HERALD
89

*An architectural drawing showing* THE HERALD *on the pediment of the Hastings-on-Hudson headquarters of the Newington-Cropsey Foundation. Architect, Rodney Cook.*

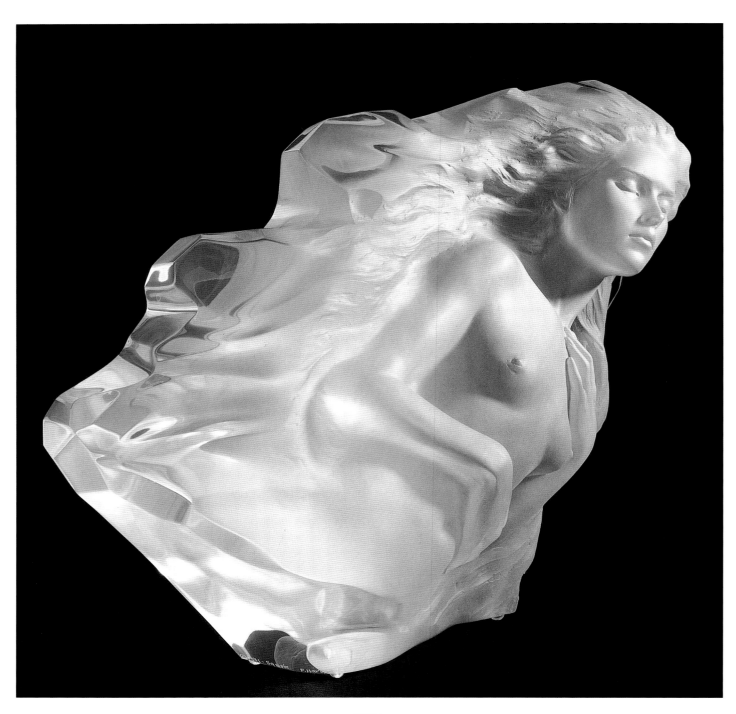

EVE
80

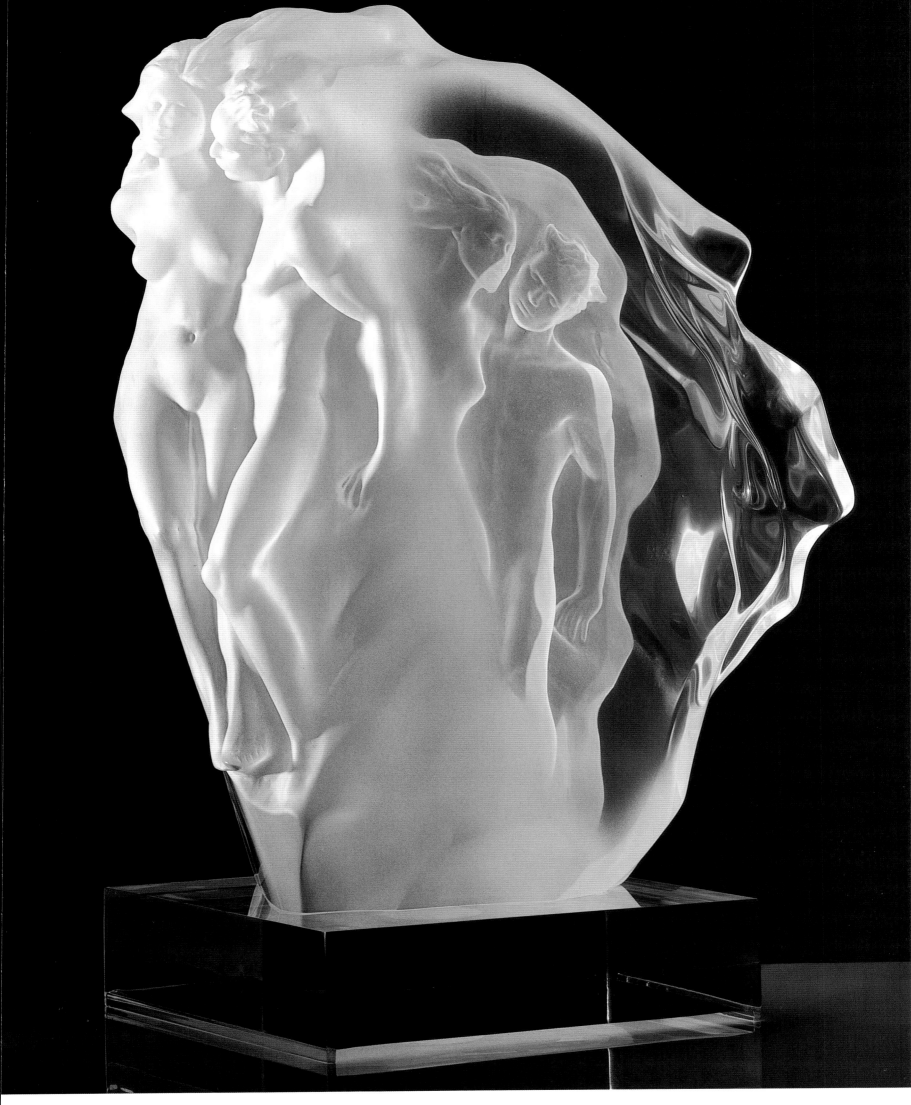

BREATH OF LIFE

*Clay maquette for* THE SOURCE

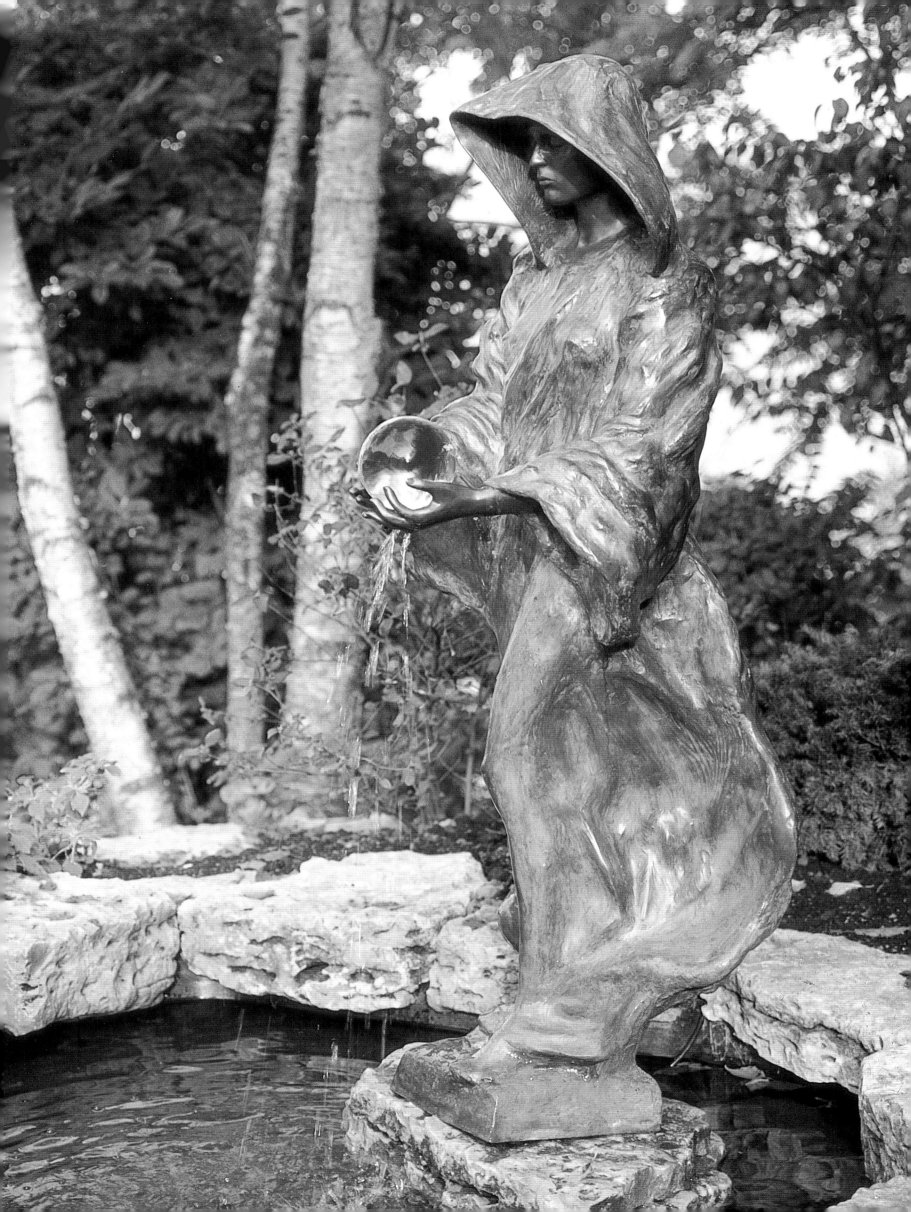

*Plaster model*
MARY EVANS
3

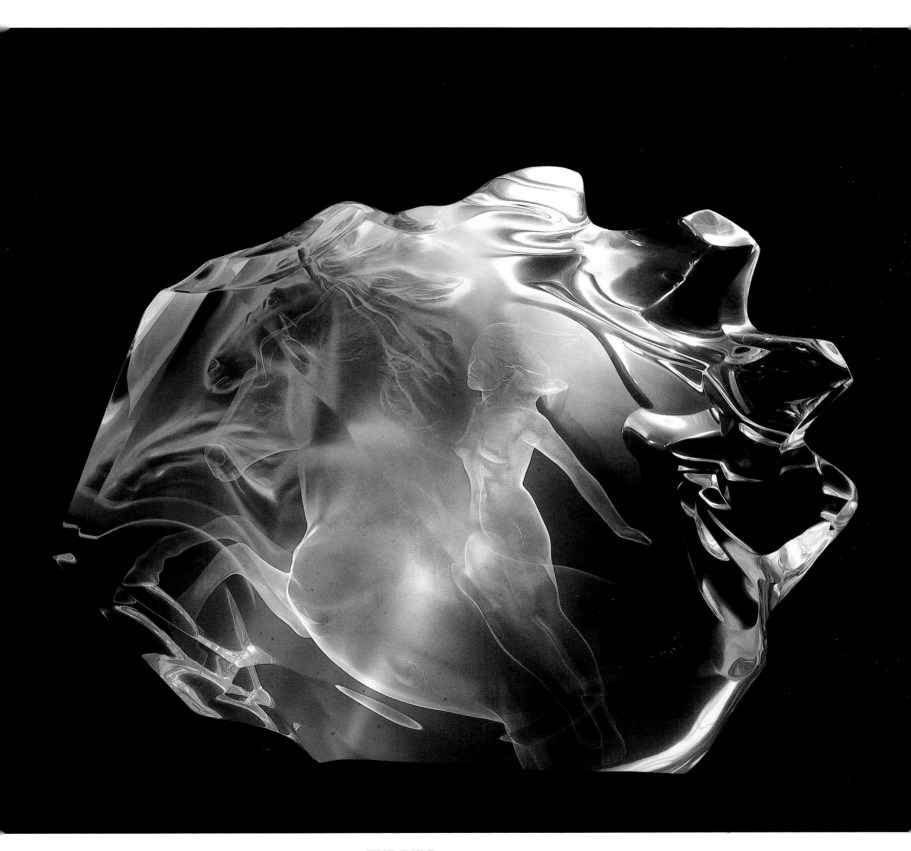

THE RIDE
72

FIREBIRD
60

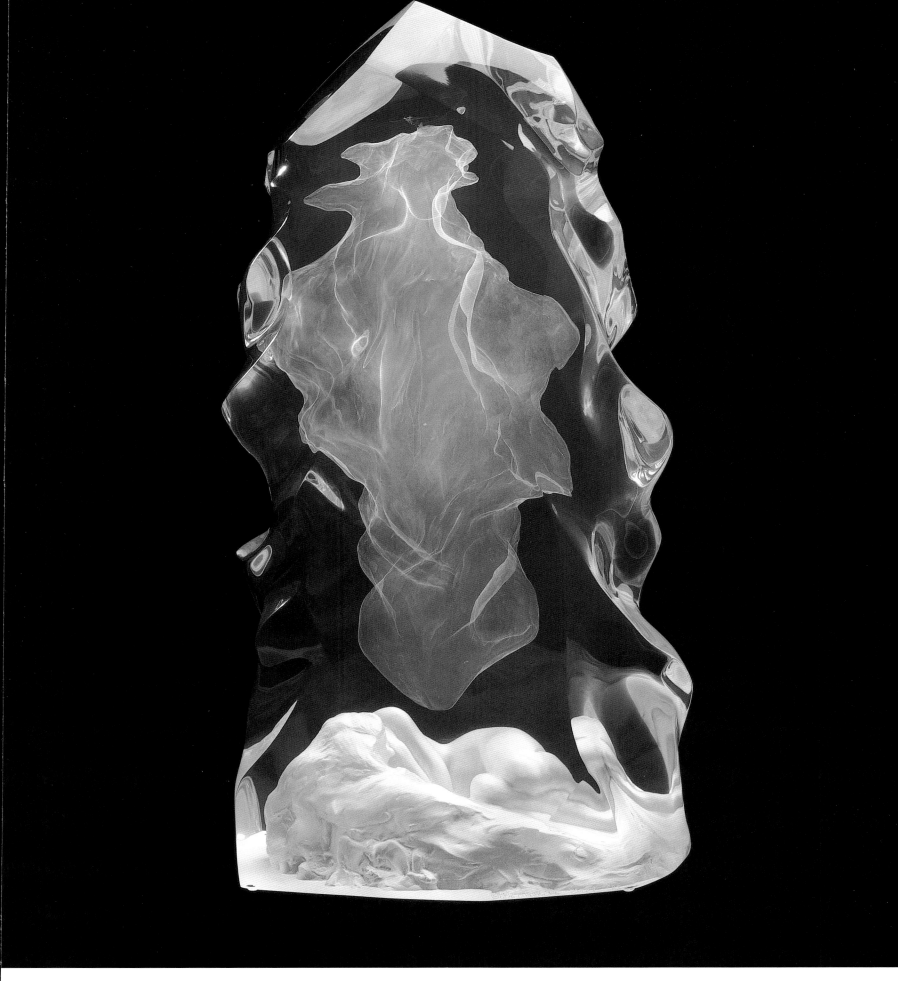

ECHO OF SILENCE
87

93

TORSO
81

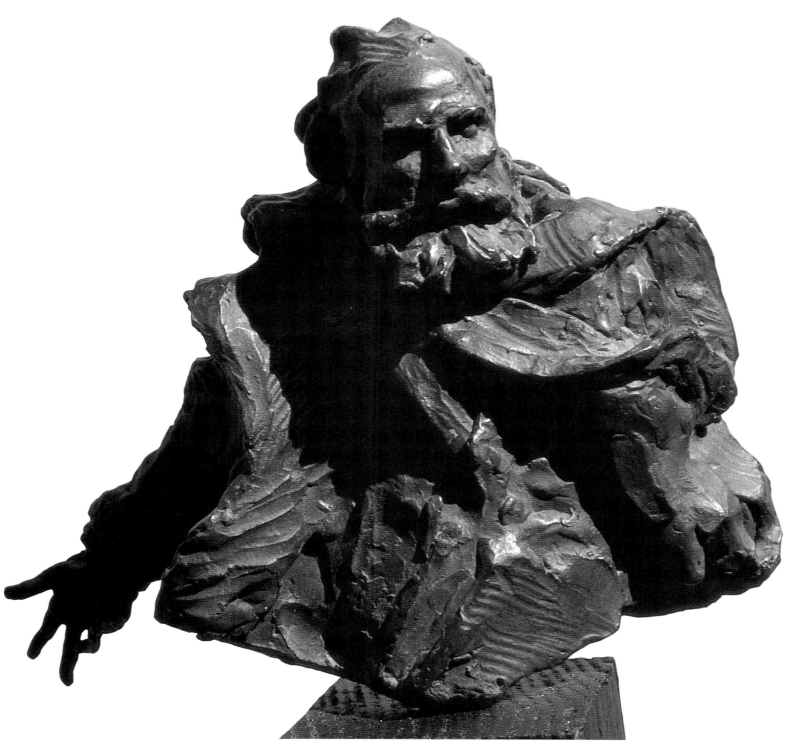

TOLSTOY
6

*Clay maquettes*
DAUGHTERS OF ODESSA
104

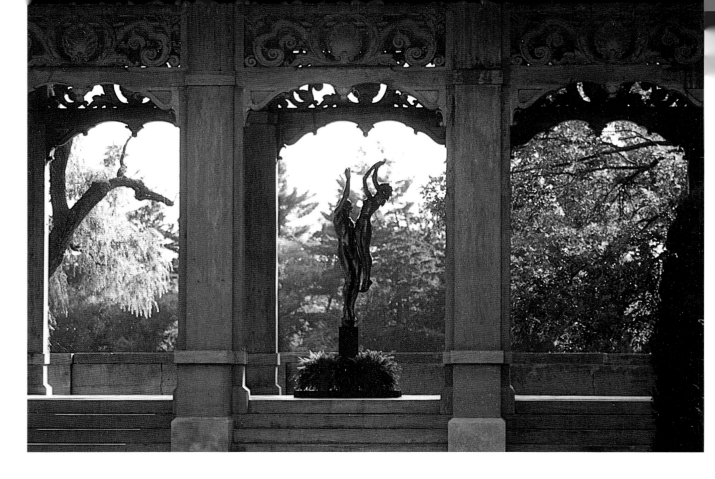

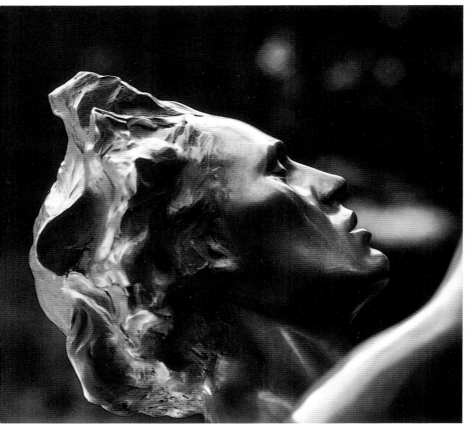

CELEBRATION
83

*Details of* CELEBRATION

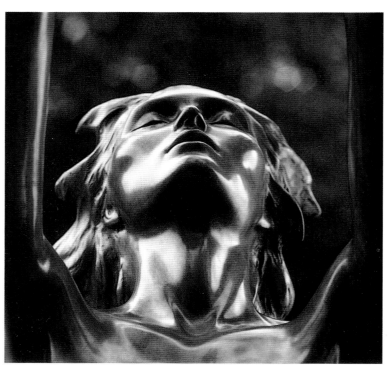

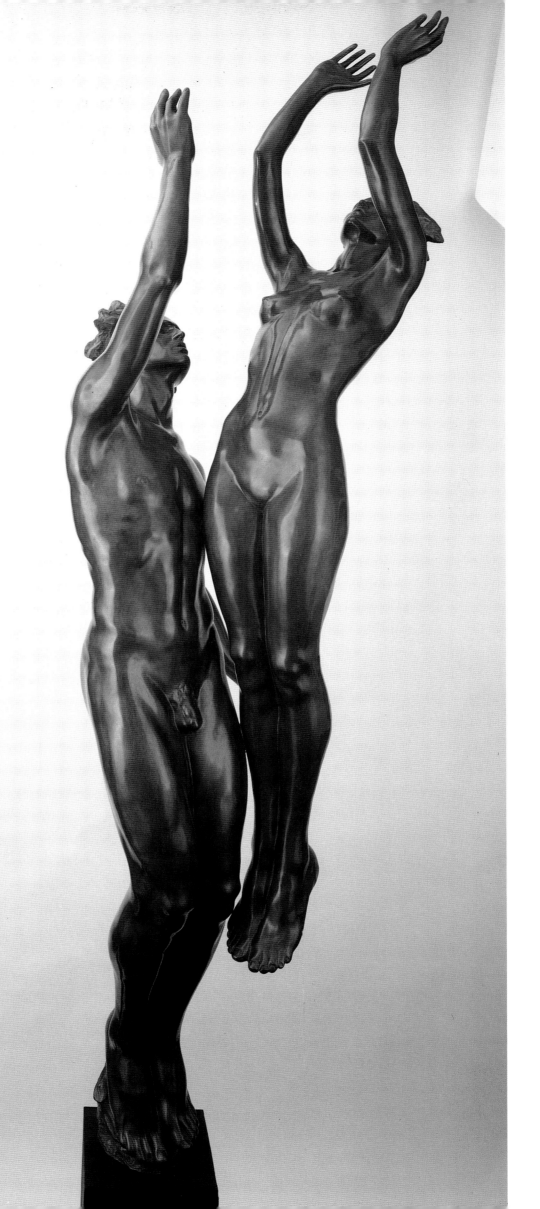

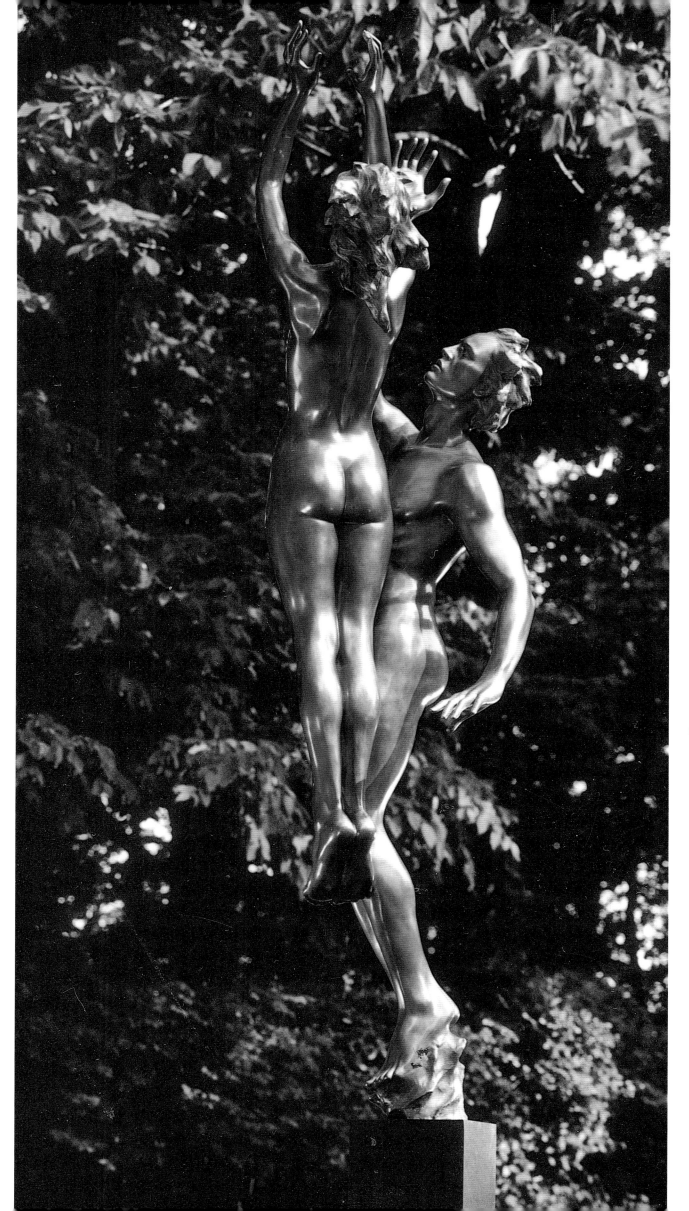

*View of* CELEBRATION
in situ

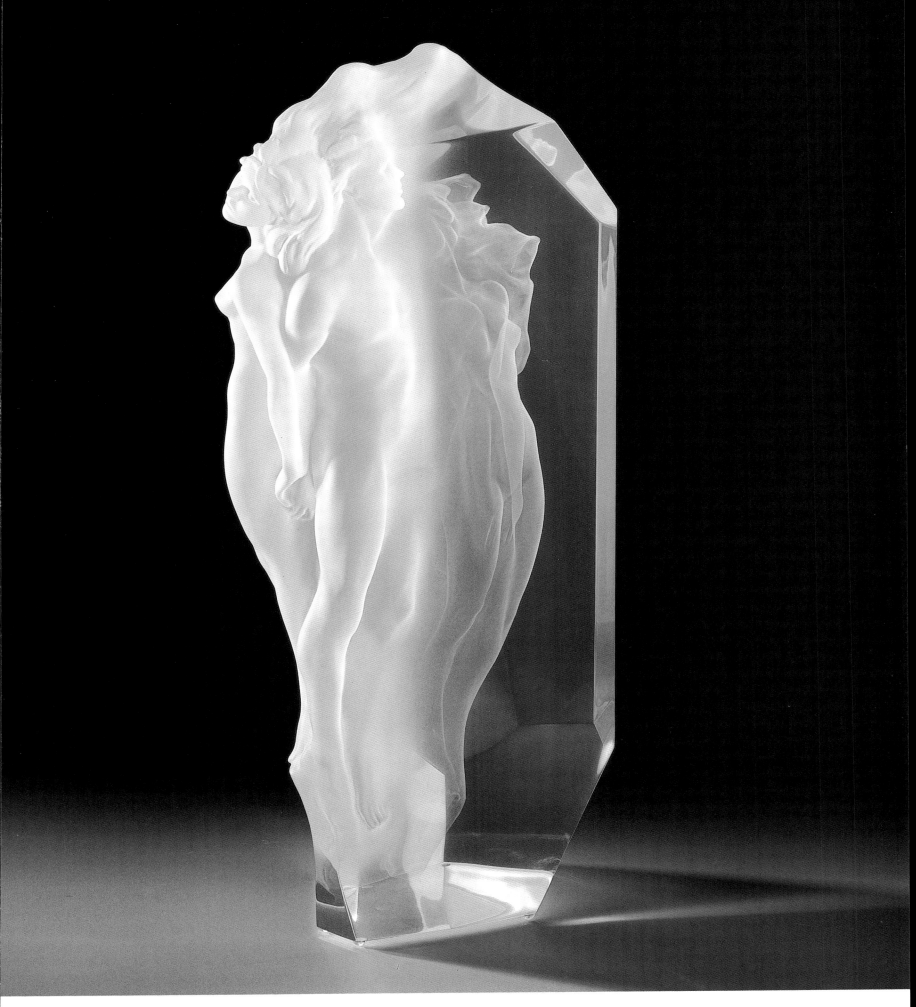

TRANSCENDENT
79

**101**

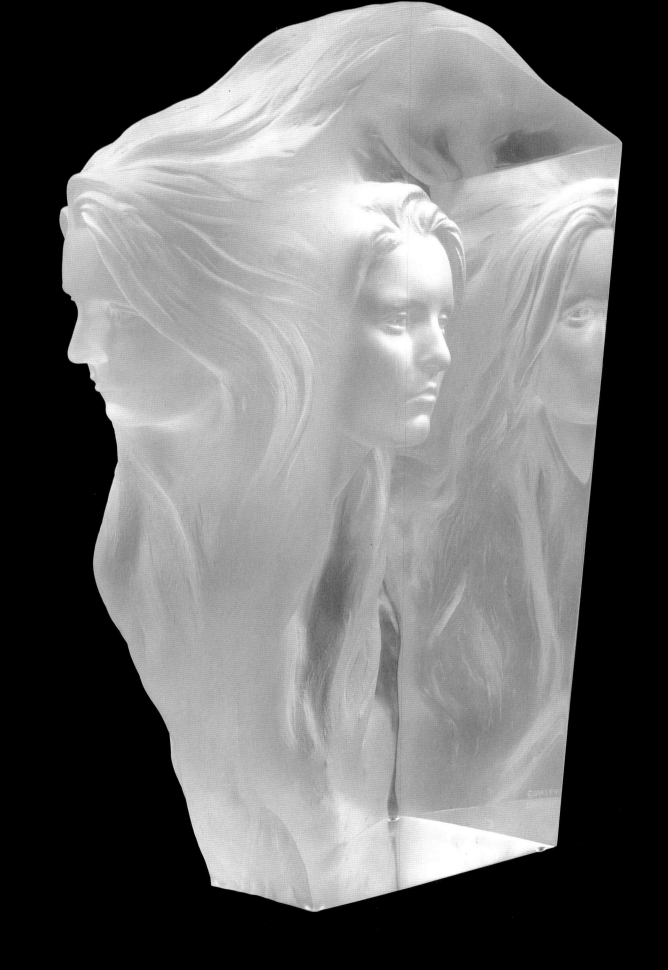

*Two views*
REFLECTIONS
100

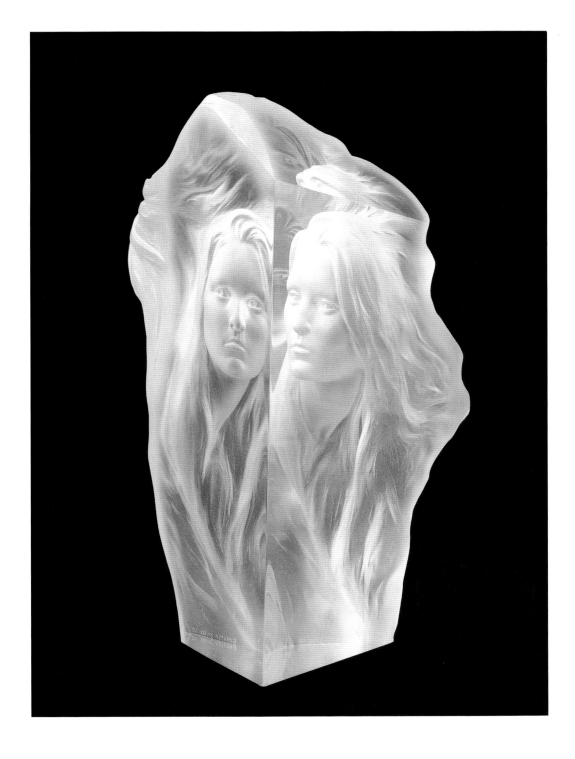

103

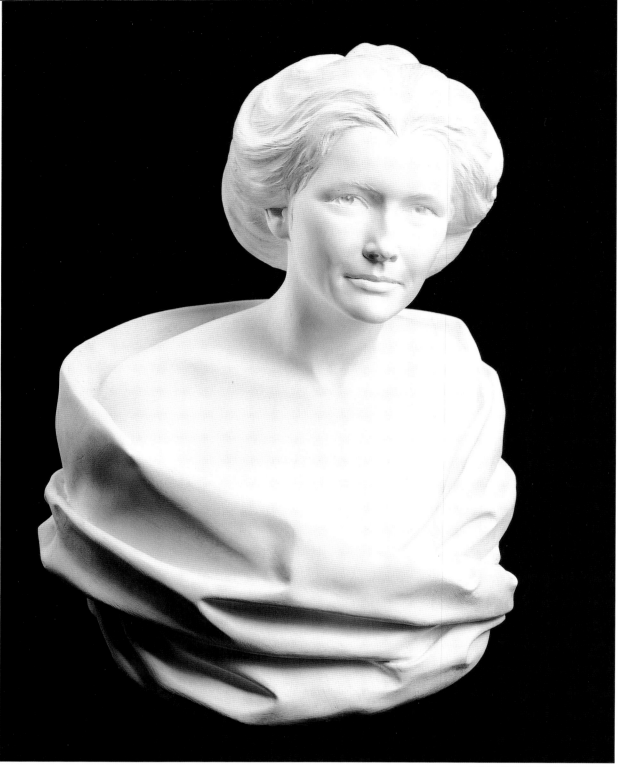

*Plaster model*
THE ARTIST'S WIFE
90

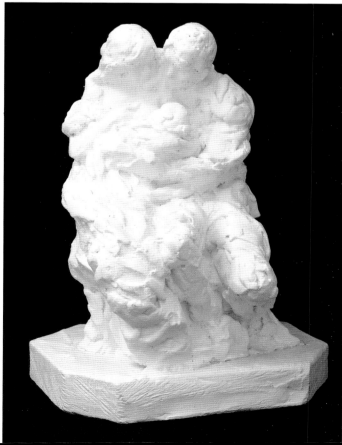

*Plaster Model*
FAMILY
7

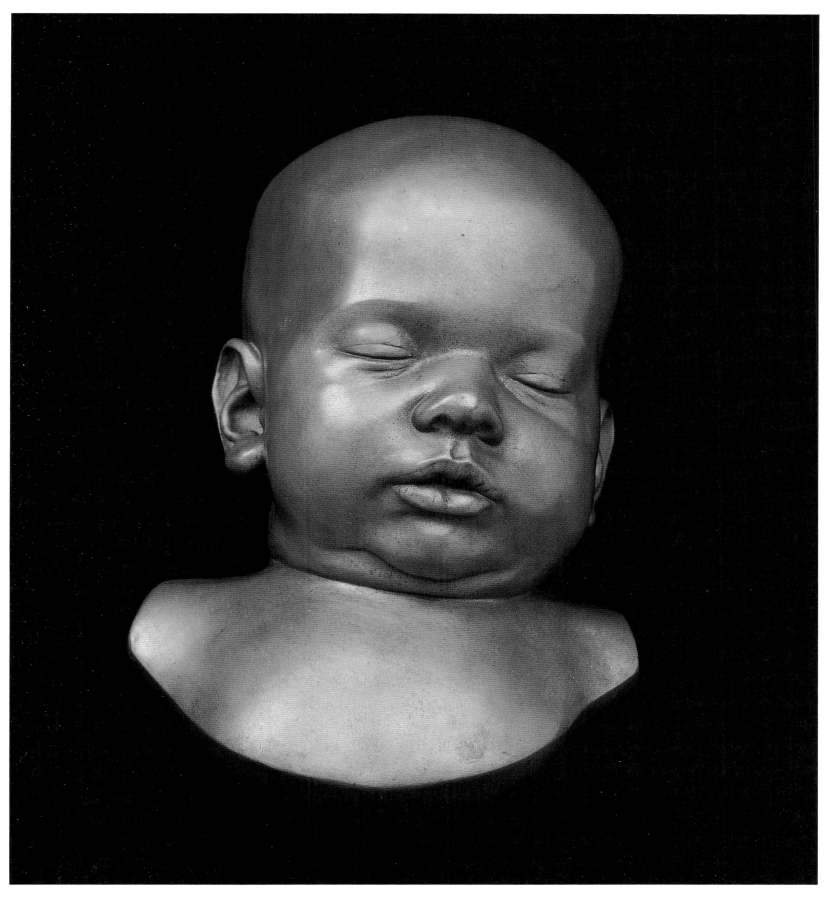

THE ARTIST'S ELDER SON
76

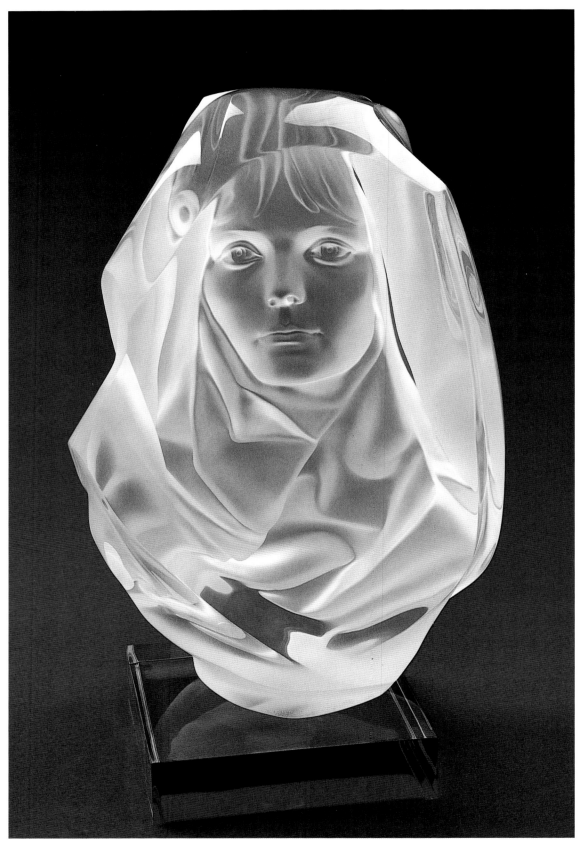

*Back view*
PENUMBRA

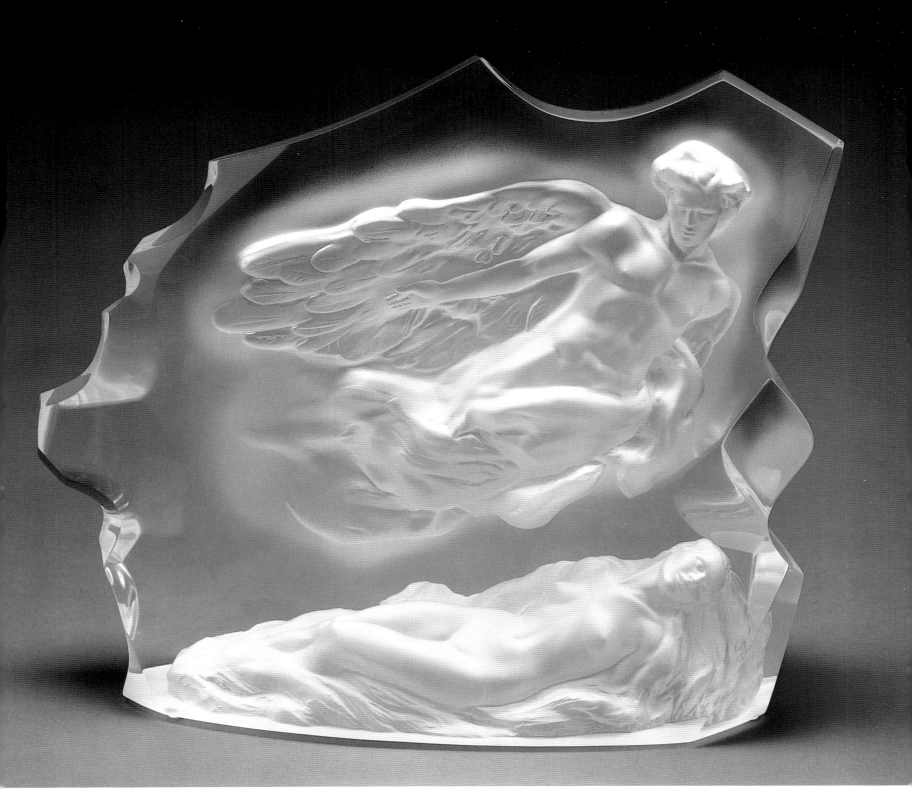

WINGED VISION
93

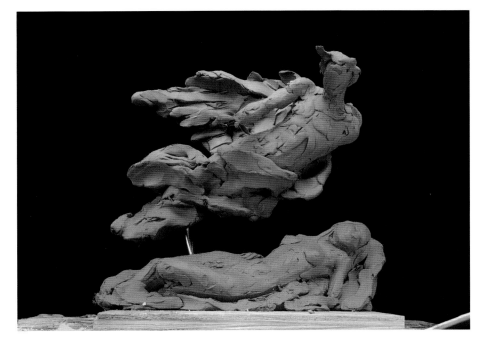

*Clay maquette for* WINGED VISION

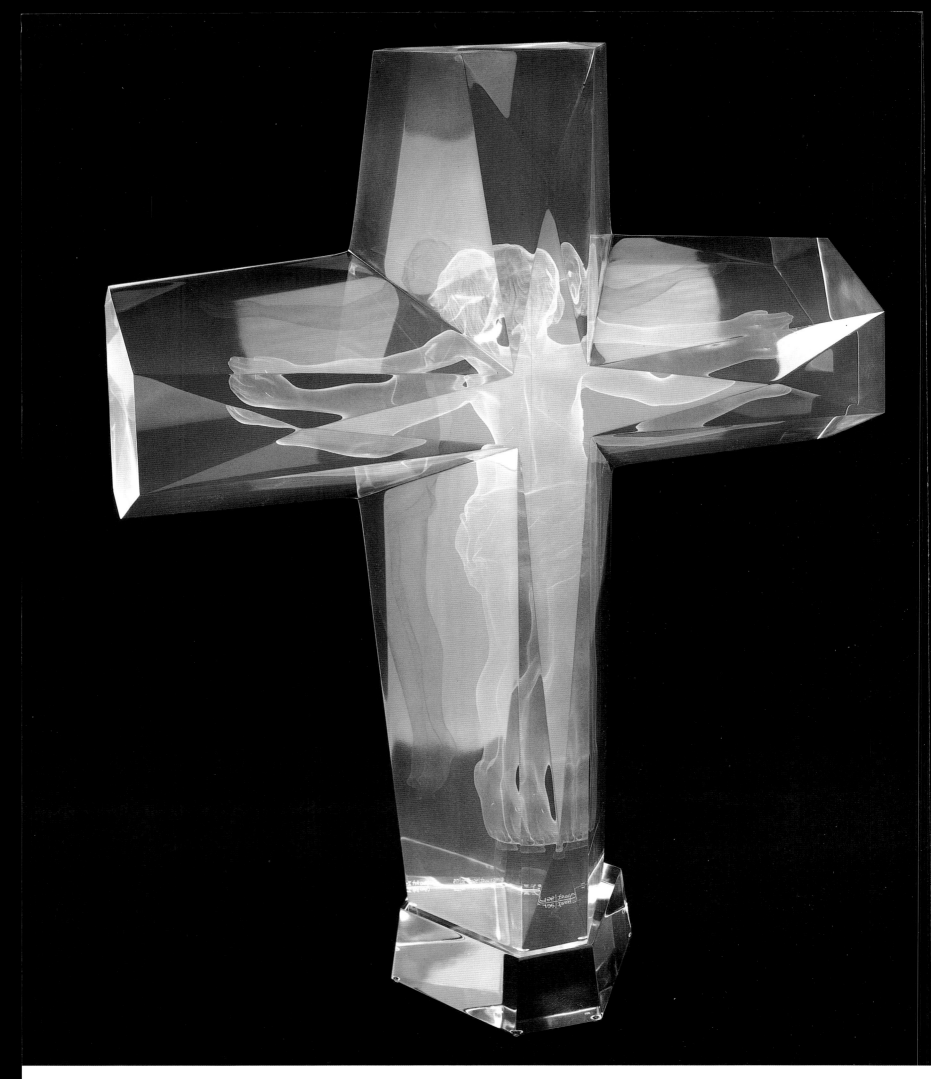

*Three-quarter view*
THE CROSS OF THE MILLENNIUM

108

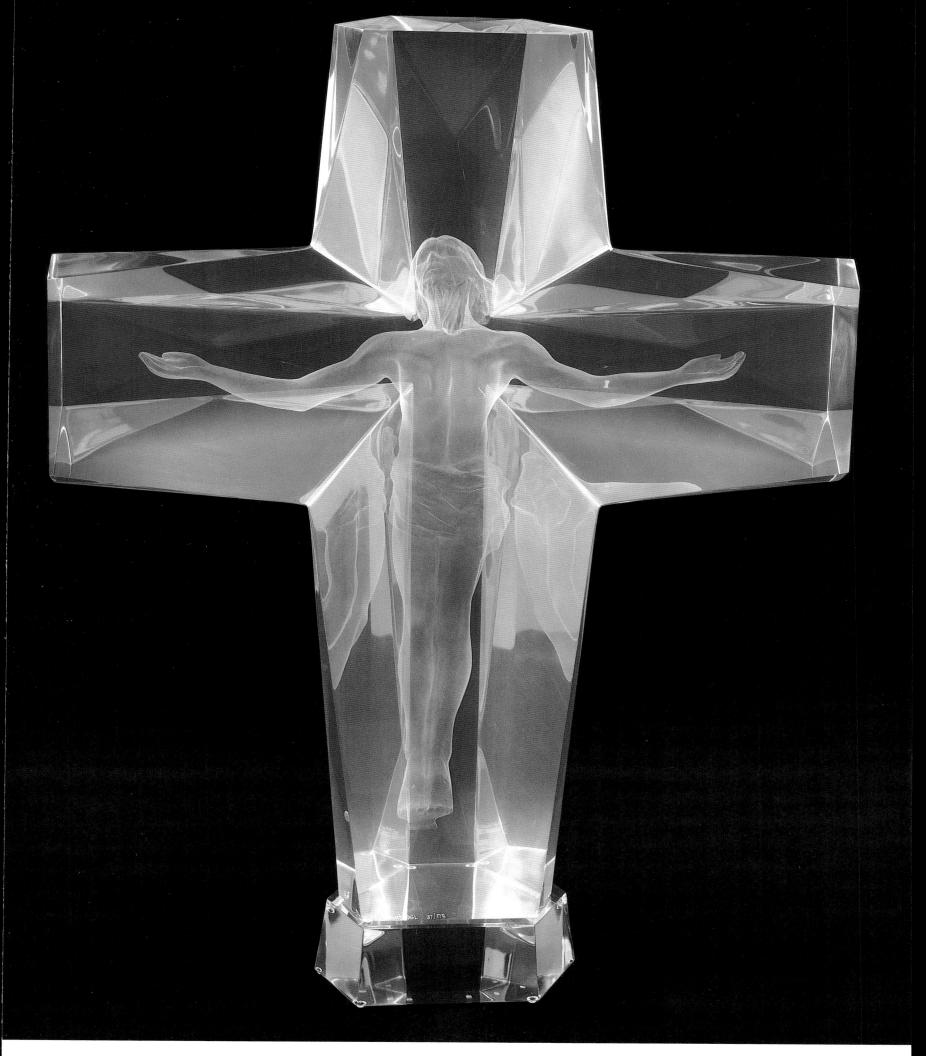

THE CROSS OF THE MILLENNIUM
84

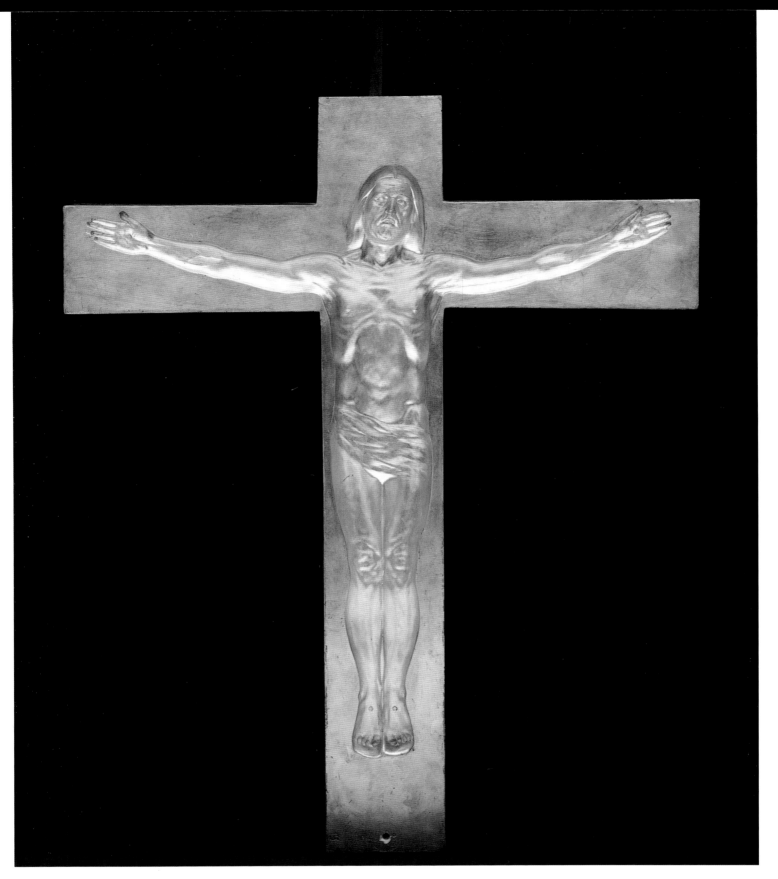

PROCESSIONAL CROSS
36

*Pope John Paul with* PROCESSIONAL CROSS

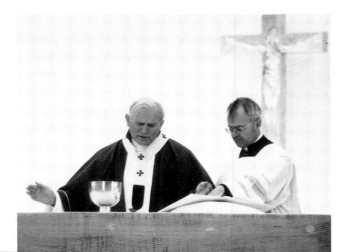

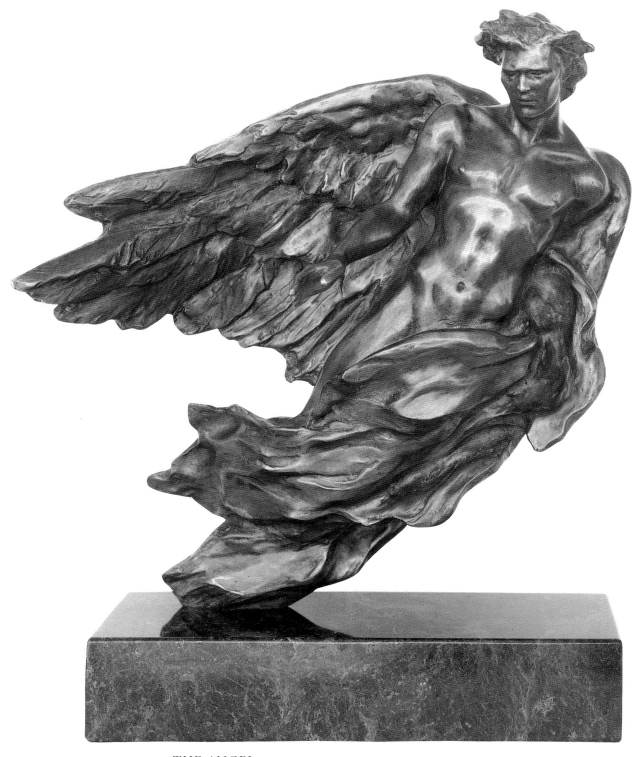

THE ANGEL
88

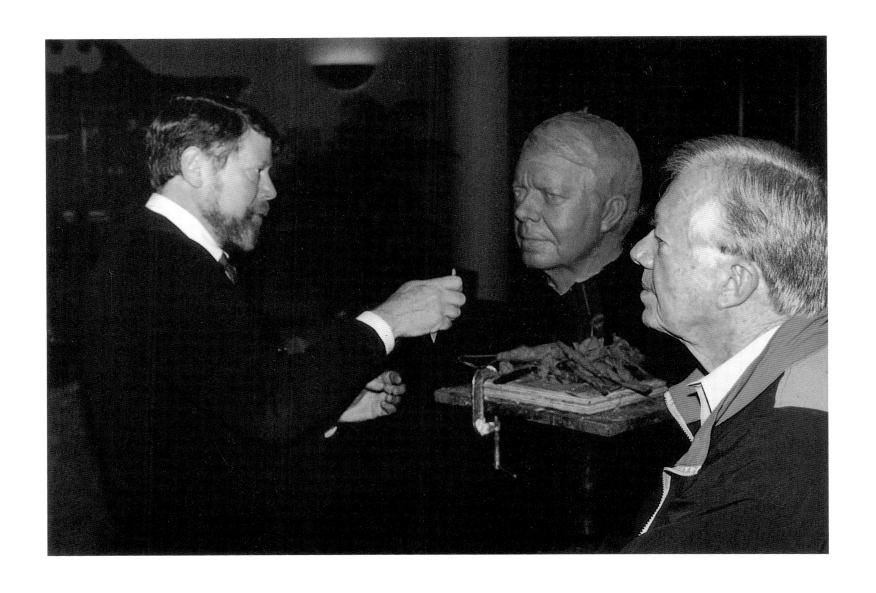

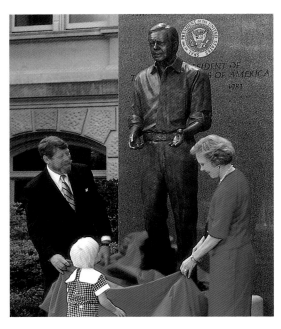

*At the unveiling of the Carter statue.*
*Left to right: Frederick Hart, Carter grandson Jamie, Mrs. Carter*

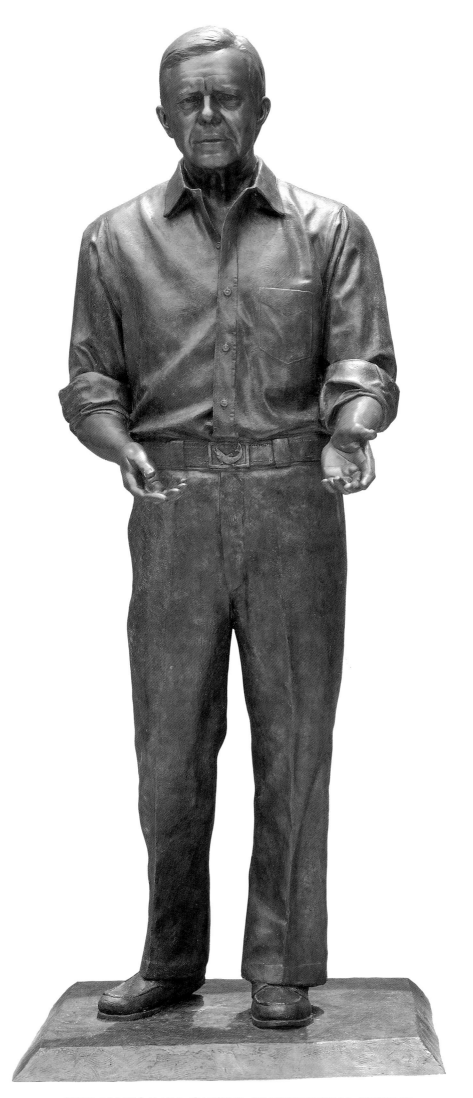

THE JAMES EARL CARTER PRESIDENTIAL STATUE
102

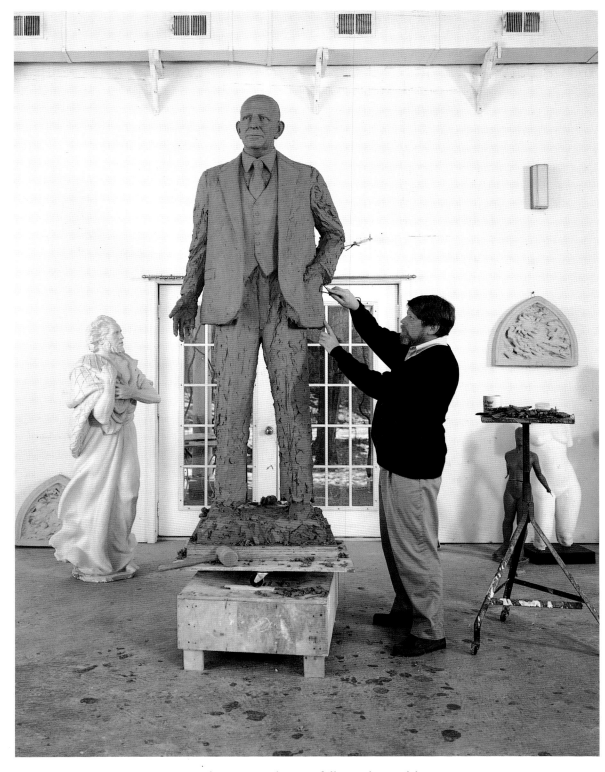

*The artist working on full size clay model*
THE RICHARD B. RUSSELL, JR. MEMORIAL STATUE

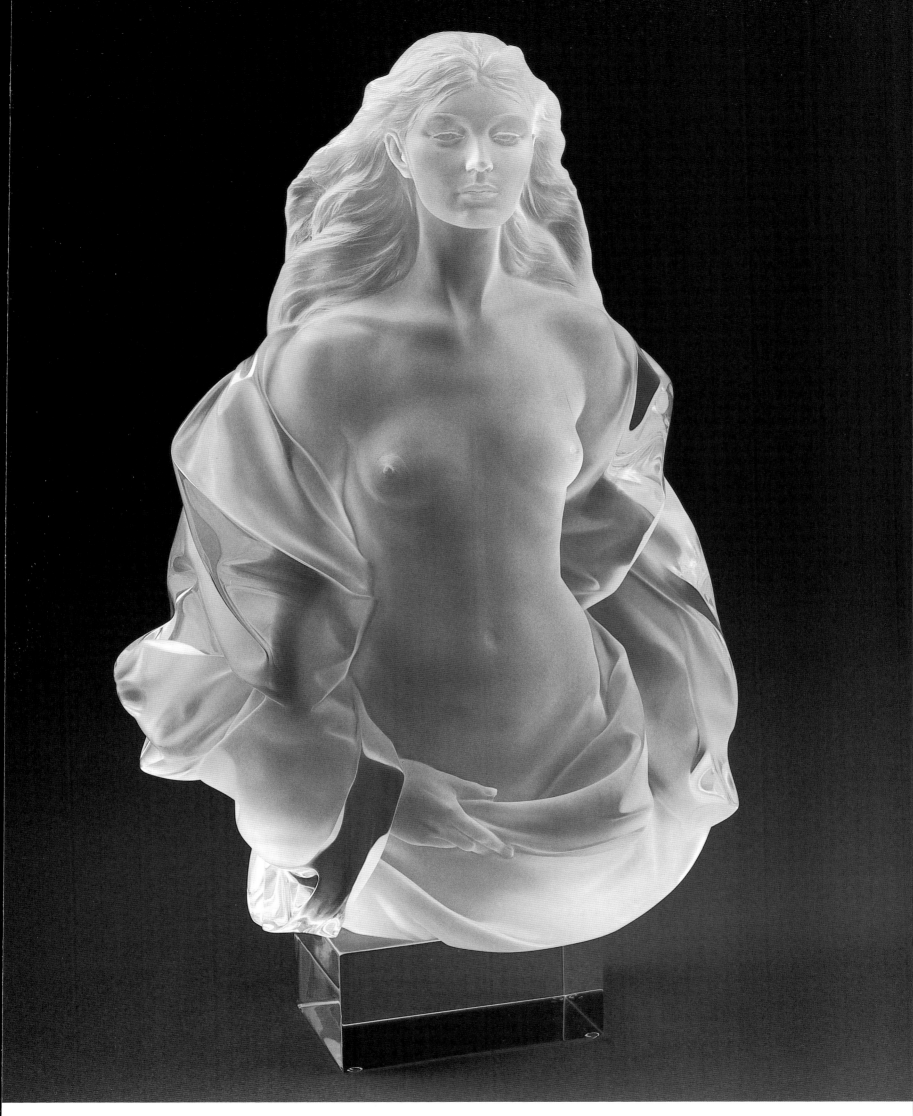

FIDELIA
66

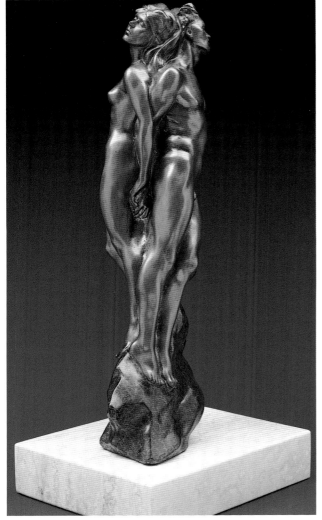

UNION
73

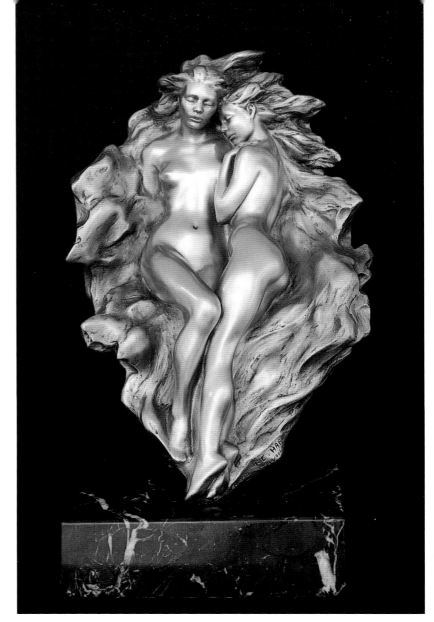

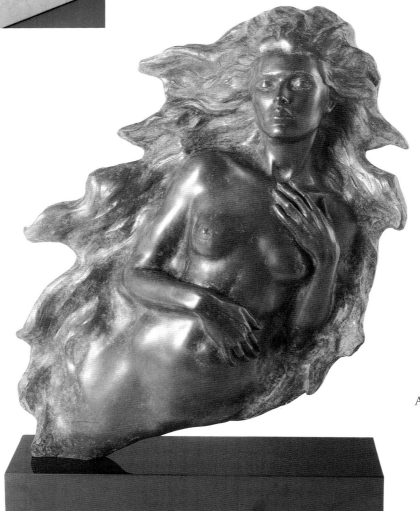

AWAKENING OF EVE
101

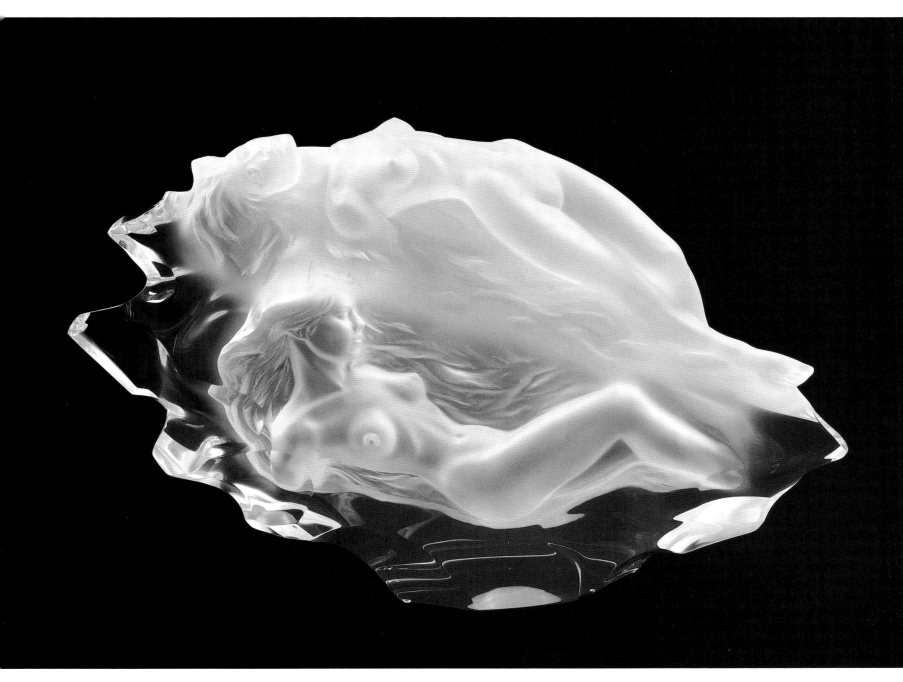

DREAMERS
92

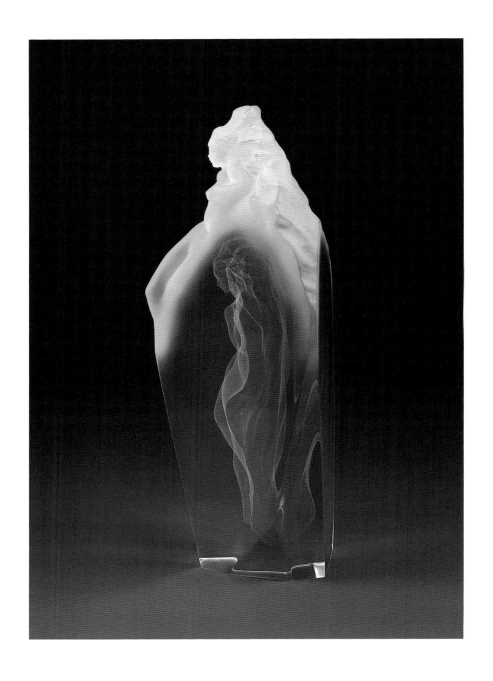

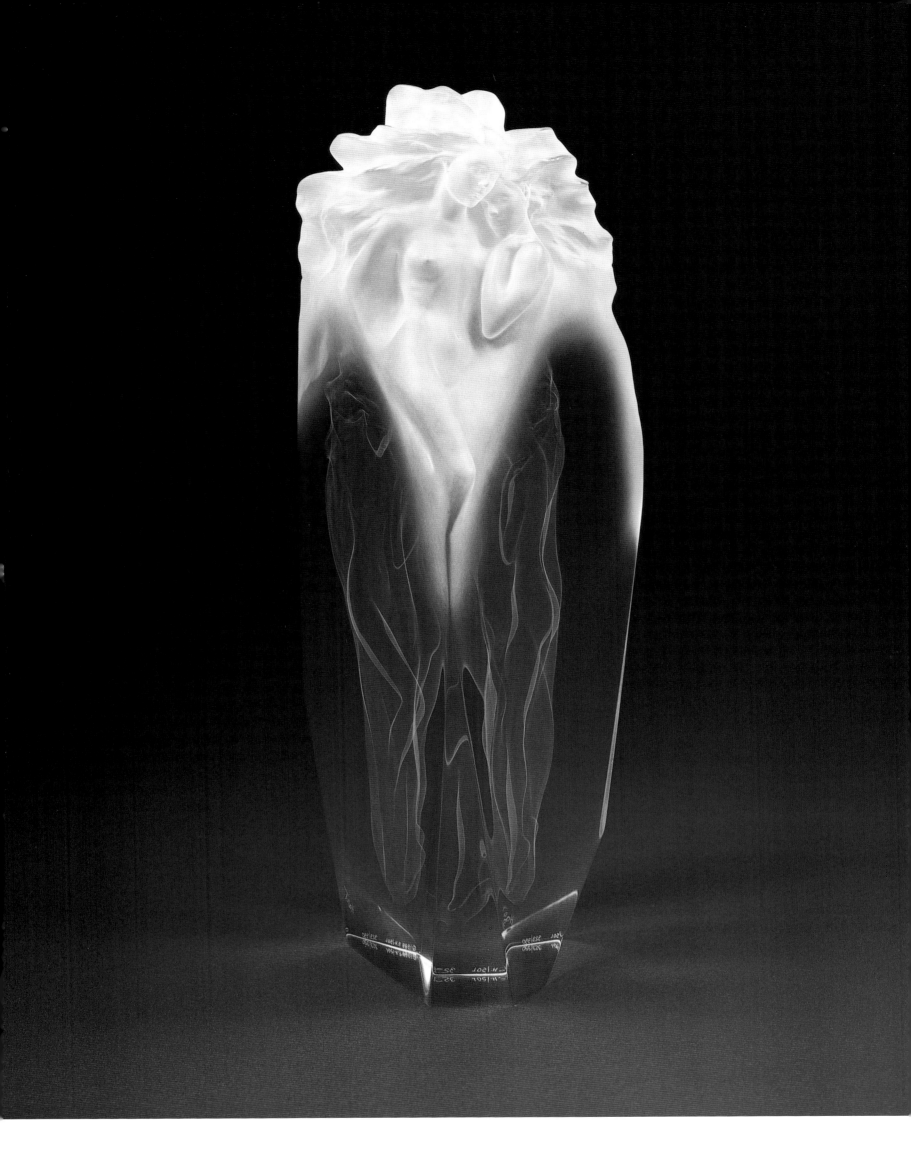

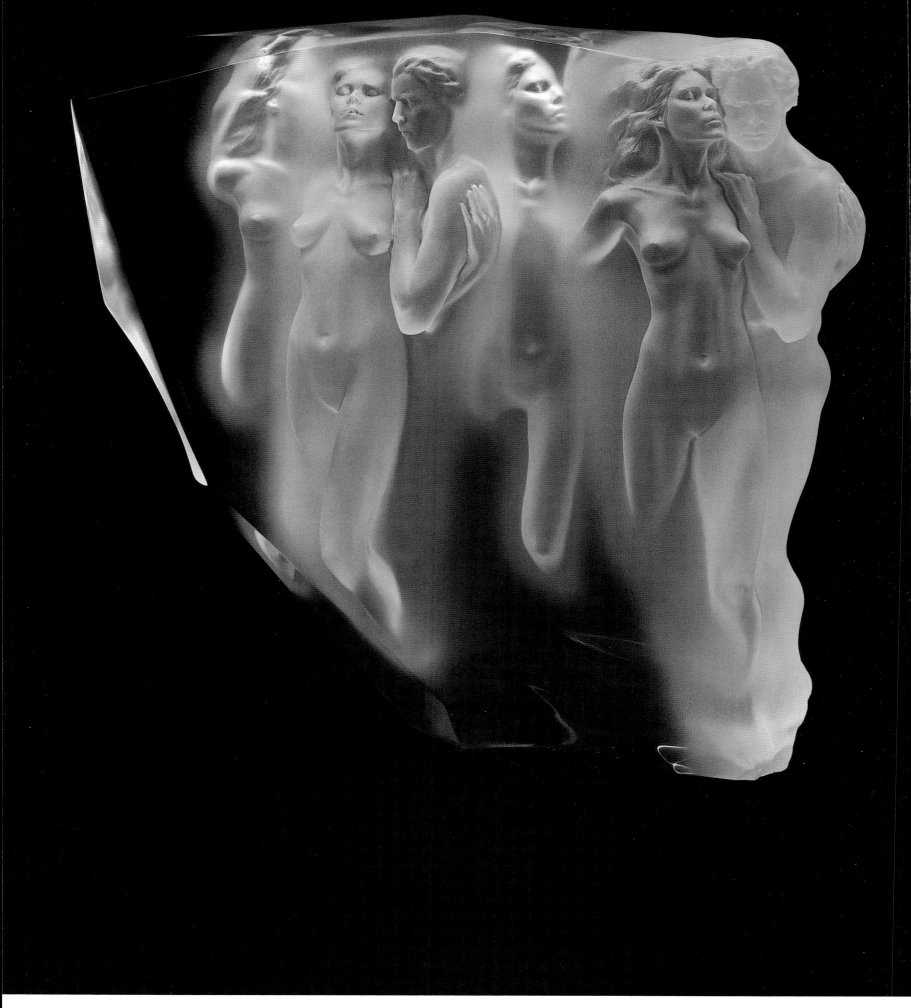

GERONTION
41

# CATALOGUE
# RAISONNÉ

COMPILED BY
## PAMELA HOYLE

# NOTES TO THE READER

1. For references to works listed in this catalogue, the correct designation is "Chesley" (abbreviated as CH followed by the catalogue number).

2. All works by Frederick Hart completed or in progress by September 1, 1994 are listed in the Catalogue Raisonné. With the exception of catalogue nos.1, 18b, 18d, 22, 27, 28, 30e, 31, 59, 71, 98, 105, 106, 107, 108, 109, 110, for which photographs were unavailable, all are illustrated in this book. The number of the page on which each work is illustrated is indicated on the catalogue page with its entry (e.g., **3**: *see page* 90), unless an illustration of the work appears on the catalogue page itself. Multiple illustrations of works are noted in the Index.

3. Because the gargoyles function as rainspouts on the walls of the cathedral and are not accessible, specific dimensions for these are not given here. The dimensions of the blocks of stone from which the gargoyles were carved are: for those located on the outside of the nave, 12 x 12 x 24 inches or 18 x 18 x 24 inches; for those located on the west facade towers, 18 x 18 x 48 inches. Because the bosses (projecting keystones decorated with carving to mask the intersection of two or more gothic vaulting ribs) are also not accessible, specific dimensions for these are not given either. None is less than ten nor more than twenty inches in diameter.

4. For works incorporated in Washington National Cathedral, (also called Cathedral Church of Saint Peter and Saint Paul), the dates published herein have been supplied by the Archives and Clerk of the Works Records at the cathedral. For editioned sculptures, the dates given have been supplied by their respective publishers.

5. The heights of sculptures include the base only for those issued in editions greater than 25. The heights of the clear acrylic resin works are approximate, as each is slightly different due to expansion and contraction inherent in the casting process, as well as the hand-finishing of each sculpture. Within an edition, the artist may vary the patina, base, position and mounting.

6. An edition comprises only published, numbered works and does not include preliminary and foundry casts. Except as noted (catalogue nos. 44, 45, 81, 82, 83, 100), numbered editions are described in Arabic numbers, artist's proofs are described in Roman numerals.

7. *Editioned works issued in a collection:*
   (referred to by catalogue numbers)

   Preludes: 37, 38, 39, 40
   Sacred Mysteries : Acts of Light: 44, 45
   The Age of Light: 51, 54, 55, 56, 58, 61, 62, 64, 65, 66, 67, 72
   The Creation Sculptures: Themes and Variations: 69, 70, 73, 74, 79, 80, 99, 101
   Dreams: Visions and Visitations: 87, 92, 93, 108

2

5

8

4

9

3: *see page* 90

6: *see page* 96

7: *see page* 104

1. **Rampant Lion**, silver, 7 inches (h), 1968, Swesink Collection

2. **Philip Hubert Frohman**, bronze, 10 1/2 inches (h), 1967-1969, collection of the Cosmos Club, Washington, D.C.

   Until he gained the attention of Frohman, architect of Washington National Cathedral from 1921 to 1971, by sculpting his portrait, Hart was a mail clerk at the cathedral. A second casting is in the Rare Book Library of the cathedral.

3. **Mary Evans**, plaster, 18 inches (h), 1968, collection of the artist

4. **Erasmus**, Indiana limestone, 32 inches (h), 1968-1969, Washington National Cathedral

   The first of many works commissioned from Hart by the cathedral, the figure of humanist scholar and religious reformer Desiderius Erasmus of Rotterdam (1466-1536) was sculpted in clay by Hart and replicated in stone by Vincent Palumbo before Palumbo became the cathedral master stone carver. It is located in the outer aisle on the south side of the nave. Erasmus writes with a quill pen in a book (in reference to his historical writings and translations). The corbel below the figure is decorated with the coats-of-arms of the Tudors and the Hapsburgs (two royal families whom Erasmus tutored) flanking a Roman style terminus figure (referring to Erasmus' humanist philosophy, and his motto *concedo nulli*). Below the terminus is a finely crafted lamp of learning resting on palm branches (alluding to his desire for peace within the church).

5. **Owl Gargoyle**, Indiana limestone, 1969, Washington National Cathedral

   Cathedral gargoyle no. 2045, sculpted and carved by Hart, is located on the exterior of the nave on the triforium level, north side, bay no. 5, west.

6. **Tolstoy**, bronze, 8 inches (h), 1969, collection of Darrell Acree

7. **Family**, plaster, 6 7/8 inches (h), 1970, collection of the artist

8. **Boss: Memorial to Major General Luther D. Miller**, Indiana limestone, 1971, Washington National Cathedral

   Cathedral boss no. 641, which Hart both sculpted in clay and executed in stone, shows an open book, an unfurled flag, a military insignia, and a five-point star. Each of the symbols refers to the military career of the general.

9. **Boss: Memorial to Mr. and Mrs. Charles C. Glover**, Indiana limestone, 1971, Washington National Cathedral

   The decision to build the cathedral was made in the home of Annie and Charles Glover on 8 December 1891. Hart sculpted cathedral boss no. 575 in clay and an unknown carver replicated his model sometime before March 1971 in stone.

10. **Gloria Siblo**, plaster, 18 inches (h), 1971, collection of the artist

11. **Peggy**, plaster, 18 inches (h), 1971, collection of the artist

12. **Leslie Weisberg**, plaster, 18 inches (h), 1971, collection of the artist

13. **David Weisberg**, plaster, 12 1/2 inches (h), 1971, collection of the artist

14. **Adam Weisberg**, plaster, 11 inches (h), 1971, collection of the artist

15. **Bradley Kamp**, plaster, 12 inches (h), 1971, collection of the artist

16. **Grotesque with Violin and Skull**, resin, 8 5/8 inches (h), 1971, collection of the artist

17. **Boss: Memorial to Robert J. Plumb**, Indiana limestone, 1972, Washington National Cathedral

    Hart both sculpted in clay and carved in stone cathedral boss no. 642, a memorial to a U. S. Navy chaplain and honorary canon of the cathedral. It shows the shield of the Episcopal Church, an anchor, and a Latin cross cordee, against a background of fruit and foliage.

18. **Four Label Mold Terminations for the Churchill Porch**, Indiana limestone, 1973-1974, Washington National Cathedral

    a. The Churchill-Marlborough Coat-of-Arms
    b. The Order of the Garter
    c. The Nobel Prize for Literature
    d. The Mace of the House of Commons

    Each symbol depicted in these label mold terminations refers to Sir Winston Churchill. Hart sculpted the symbols; Vincent Palumbo replicated 18a, 18b, 18d; John G. Guarente replicated 18c.

19. **Boss: Anglo-American Friendship**, Indiana limestone, 1974, Washington National Cathedral

    The coats-of-arms of Great Britain and the United States adorn cathedral boss no. 614 on the Churchill Porch, located on the south side of the narthex of the cathedral. Hart sculpted the work in clay, and Vincent Palumbo replicated it in stone.

18a: *see page* 20

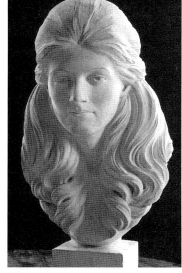

10

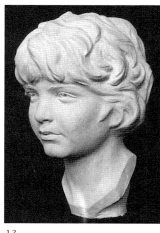

11

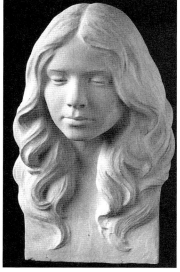

12

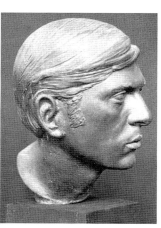

13

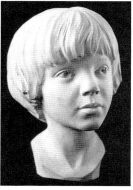

14

15

16

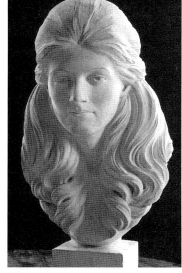

17

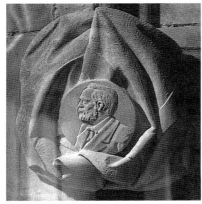

18c

19

20

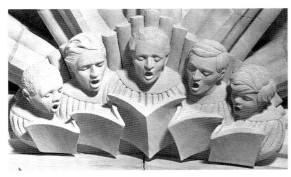

21

23

24

25

20. **Boss: Saint Andrew's Society**, Indiana limestone, 1974, Washington National Cathedral

    Cathedral boss no. 615 is decorated with thistles, oaks, and the shield of Scotland. Hart sculpted the work in clay; Constantine Seferlis replicated it in stone.

21. **Boss: Girls' Friendly Society**, Indiana limestone, 1974, Washington National Cathedral

    Cathedral boss no. 599 is inscribed with the G.F.S. motto "Bear ye one anothers' burdens," and shows the society's shield and chestnut oak leaves. Hart sculpted the boss in clay; Constantine Seferlis replicated it in stone.

22. **Boss: Dogwood Leaves, Flowers, and Branches,** Indiana limestone, 1974, Washington National Cathedral

    Hart sculpted cathedral boss no. 613 in clay; Constantine Seferlis replicated it in stone.

23. **Boss: Five Choirboys**, Indiana limestone, 1973-1975, Washington National Cathedral

    Sculpted in clay by Hart, the choirboys singing with sheet music for cathedral boss no. 619 are dedicated to the College of Church Musicians. Frank Zic replicated it in stone.

24. **Boss: The Lockwood Marriage**, Indiana limestone, 1973-1975, Washington National Cathedral

    For cathedral boss no. 617 Hart sculpted the intricately woven pattern of peonies, goldenrod, interlocking wedding bands, and a musical scroll to commemorate forty-four years of marriage for Mr. and Mrs. John Durbin Lockwood. Frank Zic replicated it in stone.

25. **Boss: Memorial to John D. Lockwood**, Indiana limestone, 1973-1975, Washington National Cathedral

    Hart sculpted cathedral boss no. 618 in clay, and Frank Zic carved English roses and a fleur-de-lys to suggest Lockwood's ancestry. A roll of photographic film and a saxophone refer to Lockwood's interests.

26. **The Child**, clear acrylic resin, 9 inches (h), 1975, collection of the artist

    Conceived in clay in 1971, *The Child* was originally cast in plaster for bronze.

**26:** *see page* 73

27. **The Annis Wilbraham Ewell Bosses Commemorating the Nicene and Apostle's Creeds**, Indiana limestone, 1975, Washington National Cathedral

  a. Tulips (cathedral boss no. 1)
  b. Flowers (cathedral boss no. 6)
  c. Vine Leaves and Flowers (cathedral boss no. 9)
  d. Tulips (cathedral boss no. 16)
  e. Leaves and Flowers (cathedral boss no. 19)
  Located in the first two bays of the center aisle of the nave, all five bosses were sculpted in clay by Hart. Constantine Severlis replicated 27a, 27b, 27e ; Severlis and Frank Zic replicated 27c; and Vincent Palumbo replicated 27d in stone.

28. **Medal**, bronze, 3 inches (h), 1975, collection of William Cardinal Baum, Archdiocese of Washington, D. C.

29. **Pan Gargoyle**, Indiana limestone, 1974-1976, Washington National Cathedral

Hart's Pan Gargoyle (cathedral gargoyle no. 39), replicated in stone by Malcolm Harlow, occupies a prominent place on the northwest tower of the cathedral, above the Creation of Day tympanum.

30. **The Palmer Bosses**, Indiana limestone, 1970-1976, Washington National Cathedral.

  a. For a Birthday (cathedral boss no. 6)
  b. For Faithfulness in the Use of the World's Goods (cathedral boss no. 233)
  c. For Those We Love (cathedral boss no.238)
  d. For Trustfulness (cathedral boss no. 240)
  e. For Joy in God's Creation (cathedral boss no. 235)
  f. For Guidance (cathedral boss no. 236)
  Donated to the cathedral in honor of Dr. and Mrs. Archie Palmer, the Palmer Bosses refer to the 1928 Book of Common Prayer. All six bosses were sculpted by Hart. No. 30a, replicated in stone by Vincent Palumbo, depicts a man and a woman cradling a child in their arms. No. 30b, replicated by Vincent Palumbo, shows two bricklayers at work. No. 30c, replicated by Frank Zic, portrays a young woman embracing elderly parents. No. 30d, replicated by Vincent Palumbo, shows a mother and child in a loving embrace. No. 30e, replicated by Vincent Palumbo, shows children clasping their hands in joy as they delight in birds and trees. Nos. 30a-e were completed in 1975. No. 30f, which shows a candle and a young man praying, was replicated by Vincent Palumbo and Patrick Plunkett in 1976.

31. **Boss: Memorial to Hibbard G. James**, Indiana limestone, 1974-1976, Washington National Cathedral

For cathedral boss no. 630 Hart sculpted a comedy mask, a lyre for light opera, the initials "G. S." for Gilbert and Sullivan, and a *Veritas* for Harvard University, all references to James' interests. Malcolm Harlow replicated Hart's concept in stone.

29: *see page* 21

30a

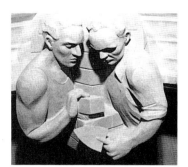

30b

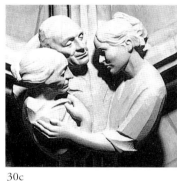

30c

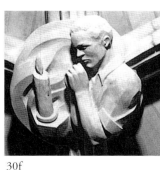

30d

30f

32

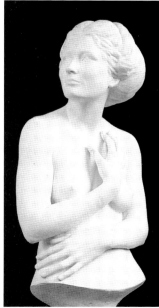

33

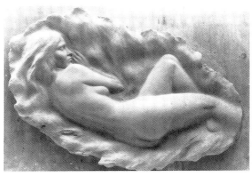

37

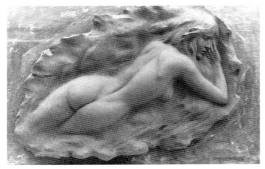

38

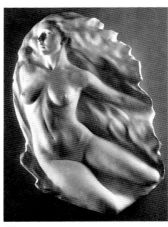 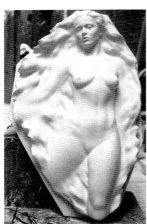

39                              40

32. **Elephant Gargoyle**, Indiana limestone, 1975-1976, Washington National Cathedral

Cathedral gargoyle no. 43, commemorating Peter F. Hewitt's tenure as manager of the cathedral bookstore, shows an elephant balancing a book on its head with its trunk. This amusing gargoyle is located on the first tower floor level of the west turret. Malcolm Harlow replicated Hart's model in stone.

33. **Lindy**, plaster, 20 1/4 inches (h), 1977, collection of the artist.

34. **Toyohiko Kagawa**, Indiana limestone, 32 inches (h), 1971-1978, Washington National Cathedral

Kagawa (1888-1960) was a Japanese social reformer, pacifist, and Protestant leader. The Kagawa niche figure is located on the north outer aisle of the nave. Vincent Palumbo replicated Hart's model in stone.

35. **Adam**, Indiana limestone, 90 inches (h), 1975-1978, Washington National Cathedral

Adam is the trumeau figure under the central tympanum on of the west facade of the cathedral. It was the first of several figures to be put in place. It was placed in its niche on 31 May 1978 and dedicated on 25 September 1978. Hart's model was the final work that Roger Morigi replicated in stone at the cathedral.

36. **Processional Cross for Pope John Paul II**, polyester resin covered with silver leaf, 38 inches (h), 1979, St. Matthew's Cathedral, Washington

The Catholic Archdiocese of Washington commissioned Hart to create this processional cross to commemorate Pope John Paul II's Mass on the Mall.

37. **Reveries**, marble-filled polyester resin bas relief, 25 inches (h), edition of 25, 1980

38. **Reflections**, marble-filled polyester resin bas relief, 25 inches (h), edition of 25, 1980

39. **Southwind**, marble-filled polyester resin bas relief, 36 inches (h), edition of 25, 1980

40. **Shadow Song,** marble-filled polyester resin bas relief, 36 inches (h), edition of 25

41. **Gerontion**, clear acrylic resin, 11 inches (h), edition of 100, plus 75 artist's proofs, 1982

Hart's first editioned clear acrylic resin sculpture was titled after a poem by T. S. Eliot.

42. **Ex Nihilo**, Indiana limestone, 156 inches (h), 1974-1982, Washington National Cathedral

Hart's first one-eighth size model for the tympanum sculpture of the central portal of the west facade was presented to the building committee in 1973 and rejected. The building committee invited Hart to present a second version in 1974, and awarded him the commission for the cathe-

34: *see page* 20

35: *see page* 33

36: *see page* 110

41: *see page* 120

42: *see page* 28

127

dral Creation program on 14 May 1974. He signed the official contract on 15 February 1975. During the remainder of 1975 and part of 1976, Hart developed the *Ex Nihilo* concept more fully, in a one-third-size version. The one-third-size model was cast in fiberglass and enlarged mechanically by Eva Montville into a rough clay version, which Hart developed into a full-size clay model, 18 x 22 feet (h), over the course of two years. In May 1979 Bruce Hoheb produced the molds for a plaster version of the final, full-size clay model. The plaster version was turned over to Vincent Palumbo in mid-January 1980. Palumbo, assisted by Walter S. Arnold, Gerald F. Lynch, and Patrick J. Plunkett, replicated it in stone *in situ*, under Hart's supervision. The stonework was completed 3 February 1982, and dedicated the following October.

43. **James Webb**, bronze, 22 inches (h), 1982, National Air and Space Museum, Smithsonian Institution, Museum Purchase with matching funds from McGraw-Hill, Inc.

The museum commissioned this portrait bust of the NASA pioneer James Webb (1906-1992). A gram of moon dust collected during the Apollo program was incorporated into the bronze during the casting process.

44. *Sacred Mysteries: Acts of Light*, Female, clear acrylic resin, 33 inches (h), edition of 100 plus 10 artist's proofs, 1983

45. *Sacred Mysteries: Acts of Light*, Male, clear acrylic resin, 30 inches (h), edition of 100 plus 10 artist's proofs, 1983

Fifty pairs are numbered in Arabic numbers, fifty in Roman numerals, and the artist's proofs are numbered in Arabic numbers. The *Male* base is 3 1/2 inches high. The *Female* base is 4 1/2 inches high.

46. **Creation of Night**, Indiana limestone, 120 inches (h), 1974-1983, Washington National Cathedral

The building committee accepted Hart's concepts for the northwest and southwest tympana on 14 May 1974, but suggested that he give the details further thought. The southwest tympanum sculpture, *Creation of Night*, dedicated 1 October 1983, was replicated in stone *in situ*, under Hart's supervision, by Vincent Palumbo, assisted by Patrick J. Plunkett, Walter S. Arnold, Laura Soles, and Lawrence Terrafranca.

47. **Saint Paul**, Indiana limestone, 65 inches (h), 1979-1983, Washington National Cathedral

*Saint Paul* is the trumeau figure under the southwest tympanum on the west facade of the cathedral. Hart was awarded the commission for Saint Paul on 15 October 1979. He completed the clay model in 1982. Master stone carver Vincent Palumbo replicated it in Indiana limestone over the course of a year, and the sculpture was set in its niche in September 1983. The southwest tympanum sculpture and the figure of Saint Paul were dedicated on 1 October 1983.

44: *see page* 75
45: *see page* 75
46: *see page* 31
47: *see page* 33

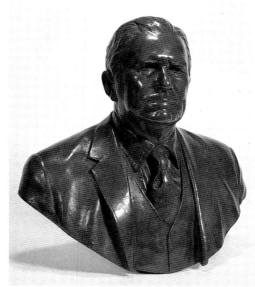

43

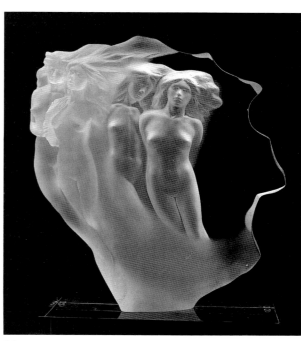

54

128

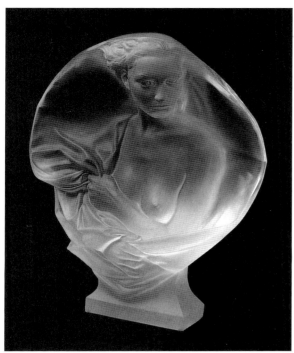

56

48: *see page* 33
49: *see page* 30
50: *see page* 74
51: *see page* 74
52: *see page* 47
53: *see page* 48
55: *see page* 77

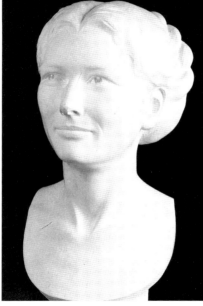

57

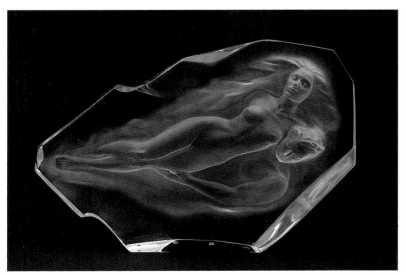

58

48. **Saint Peter**, Indiana limestone, 66 inches (h), 1977-1984, Washington National Cathedral

*Saint Peter* is the trumeau figure under the northwest tympanum, on the west facade of the cathedral. The building committee approved Hart's design for the figure 13 September 1977, and the contract was signed 19 January 1978. The replication in stone of the plaster model was accomplished by cathedral master stone carver Vincent Palumbo, and the figure was dedicated with the tympanum sculpture on 6 May 1984.

49. **Creation of Day**, Indiana limestone, 120 inches (h), 1974-1984, Washington National Cathedral

Hart's clay model was replicated under the direction of Vincent Palumbo, who oversaw the work of stone carvers Patrick J.Plunkett and Walter S. Arnold. The building committee officially accepted his updated design for the northwest tympanum on 12 December 1978. *Creation of Day* was dedicated on 6 May 1984.

50. **Herself**, bronze, 14 inches (h), 1979.

*Herself* was conceived in clay in 1971. The bronze was stolen from the artist's studio sometime after September 1979 and never editioned. In 1984 Hart sculpted another *Herself* in clay (see 51).

51. **Herself**, clear acrylic resin, 14 inches (h), edition of 300 plus 60 artist's proofs, 1984

52. **Three Soldiers**, bronze, 84 inches (h), 1983-1984, Vietnam Veterans Memorial, Washington, D.C.

Dedicated on Veterans Day 1984, the three figures stand on a ten-inch-thick black granite base made from the same type of stone used for Maya Ying Lin's wall. Bruce Hoheb made a plaster version from Hart's clay model. EDAW Landscape Architects designed the installation.

53. **Three Soldiers**, bronze, 18 inches (h), edition of 950 plus 25 artist's proofs, 1984
This is maquette for no. 52.

54. **Light Whispers**, clear acrylic resin, 17 inches (h), edition of 300 plus 60 artist's proofs, 1985

55. **Memoir**, clear acrylic resin, 12 inches (h), edition of 300 plus 60 artist's proofs, 1985

56. **Contemplation**, clear acrylic resin, 17 inches (h), edition of 300 plus 60 artist's proofs, 1985

57. **Portrait of the Artist's Wife**, plaster, 17 inches (h), 1985, collection of the artist

58. **Eye of the Flame,** clear acrylic resin, 15 inches (h), edition of 300 plus 60 artist's proofs, 1986

59. **Secrets**, clear acrylic resin, 10 inches (h) edition of 2, 1987

60. **Firebird**, bronze, 10 inches (h), edition of 350 plus 60 artist's proofs, 1987.

This is the maquette for no. 61.

61. **Firebird**, clear acrylic resin, 16 inches (h), edition of 350 plus 60 artist's proofs, 1987

62. **Passages**, clear acrylic resin, 17 inches (h), edition of 350 plus 60 artist's proofs, 1987

63. **Veil of Light**, bronze, 13 1/2 inches (h), edition of 350 plus 60 artist's proofs, 1988

This is the maquette for no. 64.

64. **Veil of Light**, clear acrylic resin, 22 inches (h), edition of 350 plus 60 artist's proofs, 1988

65. **Spirita**, clear acrylic resin, 15 inches (h), edition of 350 plus 60 artist's proofs, 1988

66. **Fidelia**, clear acrylic resin, 24 inches (h), edition of 350 plus 60 artist's proofs, 1988

67. **Visitation**, clear acrylic resin, 20 inches (h), edition of 350 plus 60 artist's proofs, 1989

68. **Penumbra**, clear acrylic resin, 18 inches (h), edition of 350 plus 60 artist's proofs, 1989

69. **First Light**, clear acrylic resin, 22 inches (h), edition of 350 plus 60 artist's proofs, 1989

70. **Genesis**, bronze, 9 1/2 inches (h), edition of 350 plus 60 artist's proofs, 1989

71. **The Ride**, bronze, 13 inches (h) edition of 350 plus 60 artist's proofs, 1990

72. **The Ride**, clear acrylic resin, 15 inches (h), edition of 350 plus 60 artist's proofs, 1990

This work was inspired by the poem of the same name by Richard Wilbur.

73. **Union**, bronze, 19 inches (h), edition of 350 plus 60 artist's proofs, 1990

74. **Breath of Life**, clear acrylic resin, 17 inches (h), edition of 350 plus 60 artist's proofs, 1990

75. **Elegy**, clear acrylic resin with sterling silver base, 23 inches (h), edition of 350 plus 70 artist's proofs, 1990

76. **The Artist's Elder Son** (Frederick Lain), bronze, 8 inches (h), 1990, collection of the artist

There are two castings to date.

77. **Mark Twain**, plaster, 13 13/16 inches (h), open edition, 1991

Comic bust for Design Industries Foundation for AIDS.

78. **Spirit of Victory**, clear acrylic resin, 25 inches (h), edition of 400 plus 40 artist's proofs, 1991

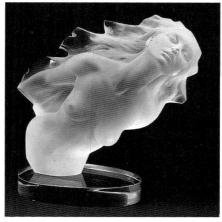
61

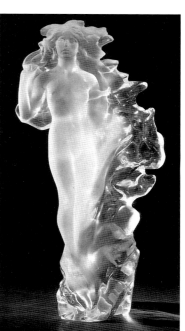
62

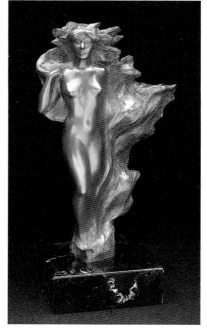
63

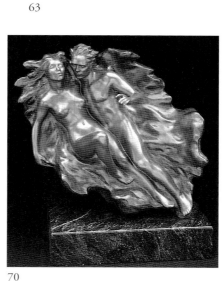
64

70

**60:** *see page* 92

**65:** *see page* 77

**66:** *see page* 115

**67:** *see page* 83

**68:** *see page* 106

**69:** *see page* 119

**72:** *see page* 91

**73:** *see page* 116

**74:** *see page* 87

**76:** *see page* 105

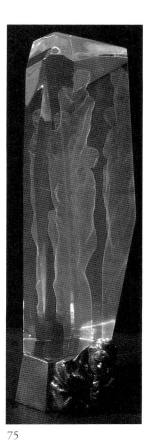

75

77

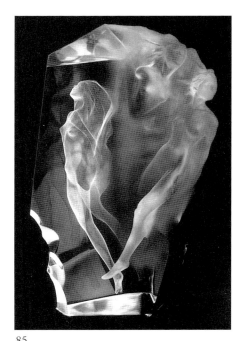

85

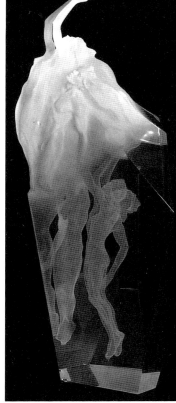

78

79: *see page* 101

80: *see page* 86

81: *see page* 95

82: *see page* 89

83: *see page* 99

84: *see page* 109

86: *see page* 78

87: *see page* 93

88: *see page* 111

89: *see page* 85

90: *see page* 104

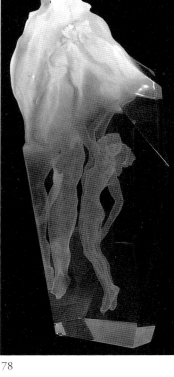

91

79. **Transcendent**, clear acrylic resin, 19 inches (h), edition of 350 plus 60 artist's proofs, 1991

80. **Eve**, clear acrylic resin, 13 inches (h), edition of 350 plus 60 artist's proofs plus 6 casts for collaborators, 1991

81. **Torso** *(female)*, bronze, 41 inches (h), edition of 8 Arabic numbers, 4 Roman numerals, 4 (A-D) for collaborators, 1991

    Conceived in clay, 1975

82. **The Source**, bronze, 66 inches (h), edition of 8 Arabic numbers, 4 Roman numerals, 4 (A-D) for collaborators, 1991

83. **Celebration**, bronze, 83 inches (h), edition of 8 Arabic numbers, 4 Roman numerals, 4 (A-D) for collaborators, 1991

84. **The Cross of the Millennium**, clear acrylic resin, 31 inches (h), edition of 175, 1992

    The size of the edition of the *Cross*, unveiled at the Easter Sunrise Service at Arlington National Cemetery in 1992, was determined by the number of member nations in the United Nations at the time.

85. **Grace of Motion**, clear acrylic resin, 19 inches (h), edition of 400 plus 40 artist's proofs, 1992

86. **Heroic Spirit**, clear acrylic resin, 26 inches (h), edition of 1000 plus 100 artist's proofs, 1992

87. **Echo of Silence**, polyester resin with clear acrylic resin, 22 inches (h), edition of 350 plus 60 artist's proofs, 1992

    This is Hart's first mixed media sculpture.

88. **The Angel**, bronze, 15 1/4 inches (h), edition of 350 plus 60 artist's proofs, 1992

    This is the maquette for no. 89.

89. **The Herald**, bronze, 50 inches (h), edition of 6 plus 1 commissioned example, 1992

    The regular edition is numbered in Arabic numbers. I/I of *The Herald* caps the pediment of the Newington-Cropsey Foundation building, Hastings-on-Hudson, New York.

90. **The Artist's Wife**, plaster, 27 1/2 inches (h), 1992

    This plaster bust will be translated into Carrera marble by Vincent Palumbo.

91. **Ascent to Victory**, 20 inches (h), each figure, 1993

    a. bronze, edition of 400 with 40 artist's proofs.
    b. silver, edition of 50 plus 6 artist's proofs.
    c. gold plated silver, edition of 10 plus 2 artist's proofs.

92. **Dreamers**, clear acrylic resin, 16 inches (h), edition of 350 plus 60 artist's proofs, 1993

93. **Winged Vision**, clear acrylic resin, 16 inches (h), edition of 350 plus 60 artist's proofs, 1993

94. **Portrait of the Artist's Younger Son**, plaster, 11 7/8 inches (h), 1993

95. **Medallion of the Artist's Wife**, plaster relief, 24 1/2 inches (d), 1993

96. **Medallion of the Artist**, plaster relief, 24 1/8 inches (d), 1993

97. **Fauquier County Veterans Memorial**, bronze decorative rail in granite base surmounted by a mahogany rail, 31 x 480 x 3 inches, 1993, Warrenton, Virginia

Hart collaborated with Jay Hall Carpenter, his former assistant, on this work, which was installed by Meade Palmer Landscape Architects.

98. **John Connor Medal**, bronze, 2 inches (d), 1993

Award designed for Operation Smile.

99. **Interlude**, bronze, 15 inches (h), edition of 350 plus 60 artist's proofs, 1993

100. **Reflections**, clear acrylic resin, 16 inches (h), edition of 1000 plus 30 for collaborators, 1994

This work was created to accompany the Deluxe Edition of the present book.

101. **Awakening of Eve**, bronze, 19 5/8 inches (h), edition of 350 plus 60 artist's proofs, 1994

102. **James Earl Carter Presidential Statue**, bronze, 76 inches (h), 1994

This statue graces the Jimmy Carter Tribute Gardens on the Georgia State House grounds in Atlanta. EDAW Landscape Architects installed the stone.

WORKS IN PROGRESS

103. **Richard B. Russell Jr. Memorial Statue**, Carrera marble, 86 inches (h)

Hart's model will be replicated by Vincent Palumbo and housed in the rotunda of the Russell Senate Office Building in Washington, D.C.

104. **Daughters of Odessa**, bronze

105. **Untitled** *(fountain figure)*, bronze

106. **Untitled** *(male torso)*, bronze

107. **Untitled** *(male head)*, bronze

108. **Untitled** (Dreams: Visions and Visitations, IV), clear acrylic resin

109. **Untitled** *(male, female pair)*, clear acrylic resin

110. **Ruby Middleton Forsythe Memorial Plaque,** bronze

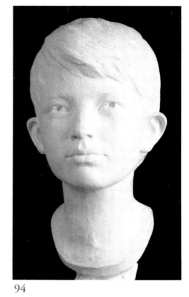

94

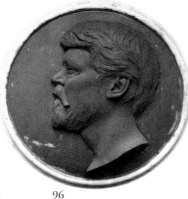

96

95

97

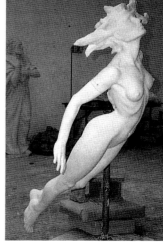

105

92: *see page* 117

93: *see page* 107

99: *see page* 116

100: *see page* 102

101: *see page* 116

102: *see page* 113

103: *see page* 114

104: *see page* 97

# FREDERICK HART

## *Chronology*

1943    Born in Atlanta, Georgia, to Joanna Elliot and Frederick William Hart.

1960-66    Attends the University of South Carolina, Columbia, the Corcoran School of Art, and American University, Washington, D.C.

1966-68    Apprenticeships with sculptors Giorgio Gianetti, Felix de Weldon, Carl Mose, Don Turano, and Heinz Warnecke.

1968-71    Apprentice stone carver and sculptor at Washington National Cathedral, Washington, D.C.

1971    Begins to experiment with clear acrylic resin as a medium for sculptural expression.

1972    Opens sculpture studio in Washington and begins executing commissioned works.

1974    Wins international competition to design the sculptural program for the main entrance, west facade, of Washington National Cathedral. The program comprises three life-size statues, *Adam, Saint Peter,* and *Saint Paul*, and three relief panels, *Creation of Night, Creation of Day,* and *Ex Nihilo* (Out of Nothing).

1976    Appointment to the Sacred Arts Commission for the Catholic Archdiocese of Washington.

1979    Creates processional cross for Pope John Paul II's historic mass on the Mall in Washington.

1980    Submits proposal to national competition for commission of Vietnam Veterans Memorial, which places third among 1,430 entries.

1982    Creates first clear acrylic resin work, *Gerontion.*

Receives commission for a figurative sculpture to be placed at the Vietnam Veterans Memorial on the Mall in Washington.

Receives commission for bronze bust of James Webb of NASA from National Air and Space Museum, Smithsonian Institution, Washington.

1983    Creates Sacred Mysteries: Acts of Light (*Male* and *Female*), a suite in clear acrylic resin.

1984    *Three Soldiers* is installed at the site of the Vietnam Veterans Memorial on the Mall in Washington and dedicated by President Ronald Reagan.

Receives commission for The Age of Light, a series of twelve sculptures in clear acrylic resin.

1985    Appointment by President Ronald Reagan to a five-year term on the Commission of Fine Arts, a seven-member committee that advises the United States Government on matters pertaining to the arts and guides the architectural development of the nation's capital.

1986    Appointment to the board of trustees, Brookgreen Gardens, Murrell's Inlet, South Carolina (foremost outdoor collection of American sculpture).

1987    With Philip Frohman, Architect of Washington National Cathedral from 1921 to 1971, receives Henry Hering Award for the Creation sculptures from National Sculpture Society, New York.

Participates in *100 Years of Figurative Sculpture*, an invitational exhibition in Philadelphia in conjunction with the Bicentennial of the United States Constitution.

1988    Receives the Presidential Award for Design Excellence, given once every four years, for *Three Soldiers*.

1989    Receives commission for The Creation Sculptures: Themes and Variations, a series of eight sculptures ( four acrylics and four bronzes ).

1991    Creates and donates a comic bust of Mark Twain for the Design Industries Foundation for AIDS (DIFFA).

Completes three life-size bronze sculptures: *The Source, Torso*, and *Celebration.*

1992    Receives commission for Dreams: Visions and Visitations, a series of four sculptures in clear acrylic resin.

Unveils *The Cross of the Millennium* at the Easter Sunrise Service, Arlington National Cemetery, Virginia.

Agrees to create and donate a portrait study for the *Ruby Middleton Forsythe Memorial Plaque*, honoring an educator who devoted her life to teaching underprivileged youth in a one-room schoolhouse in Murrell's Inlet, South Carolina

(see Brian Lanker, *I Dream a World: Portraits of Black Women Who Changed America,* 1989*).*

Completes maquette for a proposed monumental statue and fountain honoring all American Olympic athletes to commemorate the 100th Anniversary of the Modern Olympic Games to be held in Atlanta, Georgia in 1996.

1993   Receives commission to create the *Richard B. Russell, Jr. Memorial Statue,* a larger-than-life-size marble of the late senator, for the rotunda of the Russell Senate Office Building in Washington.

*The Cross of the Millennium* is selected as the Best of Show and Visitors' Choice in Sacred Arts XIV, the nation's largest annual juried exhibition of religious art. The Cross is the first work of art ever to receive both awards simultaneously.

Billy Graham Center Museum, Wheaton, Illinois, adds *The Cross of the Millennium* to their permanent collection.

In collaboration with Jay Hall Carpenter, his former assistant, completes and donates *A Tribute to Desert Storm,* a decorative sculptural railing, to the Fauquier County Veterans Memorial, Warrenton, Virginia.

Receives the George Alexander Memorial Award from the Blinded American Veterans Foundation for service on behalf of all veterans, particularly those with sensory disabilities.

Completes and donates to Operation Smile International the *John Connor Memorial Medal,* a bronze medal commemorating the Vietnam veteran, which will be awarded to individuals who have provided exceptional service to children who need reconstructive surgery.

Receives honorary degree of Doctor of Fine Arts from the University of South Carolina for his "ability to create art that uplifts the human spirit, commitment to the ideal that art must renew its moral authority by rededicating itself to life, skill in creating works that compel attention as they embrace the concerns of mankind, and contributions to the rich cultural heritage of our nation".

1994   Completes the James Earl Carter Presidential Statue, a larger-than-life-size bronze, commissioned for the grounds of the state capitol in Atlanta, Georgia.

Completes *The Herald,* a bronze angel, commissioned to be placed above the entrance to the Newington-Cropsey Foundation Gallery and Cultural Studies Center, Hastings-on-Hudson, New York.

# Profile

The traditions of Southern country life have remained with Frederick Hart ever since his birth in Atlanta and youthful years in the plantation country of South Carolina. In 1987 that tradition was continued when he built a home on 135 acres of open farmland and rolling hills nestled at the foot of the Blue Ridge Mountains in the Piedmont region of northern Virginia. The estate is named Chesley, in remembrance of his late sister.

Hart's home is testimony to the great traditions of English and European country homes, strongly influenced by Hart's love for eighteenth-century Russian art and architecture. It was envisioned to be not only a center for family life, but a natural environment for the creation of art and a gathering place for the exchange of ideas and visions. The estate is itself a work of classical art in evolution. Sweeping vistas and colonnaded porches lead to a richly ornamented interior, complete with plaster work gilded and polychromed in the old world tradition. The woodland and formal sculpture gardens that Hart is now developing have inspired him to create life-size bronzes to be used as fountains and graceful additions to flower gardens, pools, and ponds.

Chesley epitomizes Hart's deeply held beliefs about beauty, tradition, and permanence. Although the estate is an ideal setting for the frequent gatherings that Hart hosts for the "Centerists", a group of artists, poets, philosophers, and others who share his vision, personal gestures abound. Medallions of himself and his family members have been incorporated into the exterior architecture of the home, and plans are underway to build a family chapel and cemetery.

Hart's studio, while an integral part of Chesley, is a separate building in a secluded hollow near the home. The light-filled space affords abundant testimonies to the artist's creative energies, in the form of completed plasters of his monumental sculptures as well as an array of works in various stages of completion.

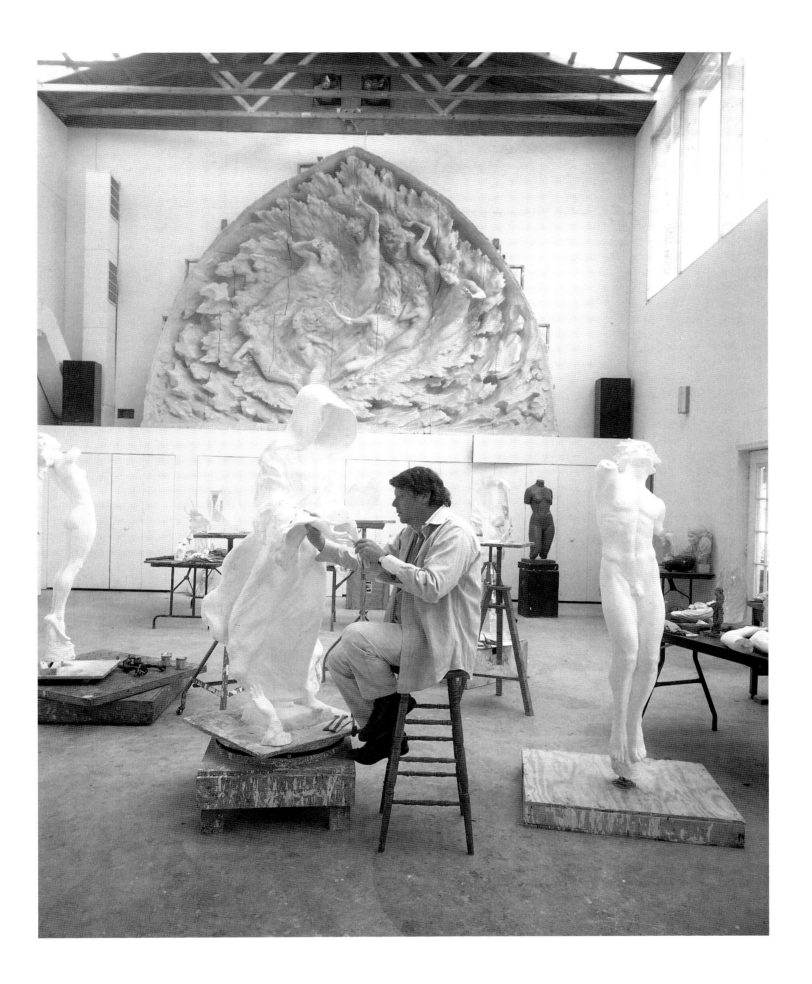

*Chesley, the Hart residence in the Piedmont area of Virginia,
named in memory of the sculptor's sister, who died in her teens*

*Hart's studio at Chesley*

*Hart and his family with their horses*

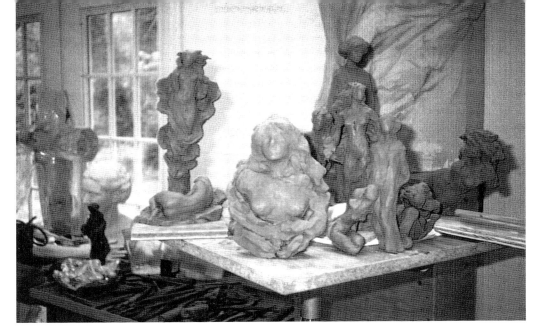

*Maquettes of Hart sculptures*

*Trustee Frederick and Lindy Hart and Robert and Moya Chase attending annual members' reception at Brookgreen Gardens, South Carolina*

*Chase and Hart in his studio discussing maquette for* Dreams IV

*The Hart family having tea in the conservatory at Chesley. Left to right: F.H., Zander, Lindy, Lain.*

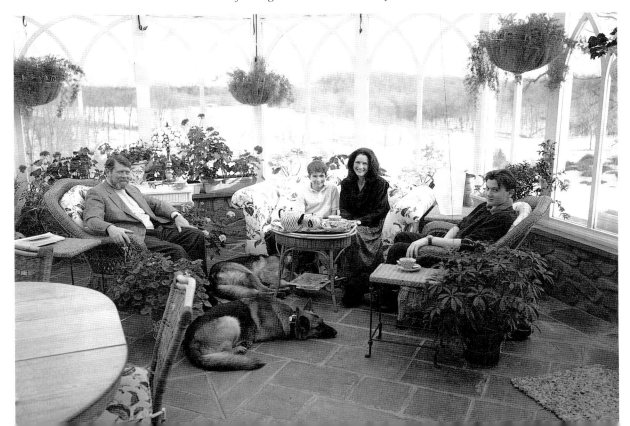

# Bibliography

Anonymous. "Creating the Creation." *Cathedral Age* (summer 1980).

————."Vietnam Memorial War." *Art News* 82 (January 1983).

Bellows, Henry W. "Seven Sittings with Powers, the Sculptor." *Appleton's Journal of Literature, Science, and Art* 12, 14 (1869), pages 402, 595-597.

Brown, J. Carter. "The Mall and the Commission of Fine Arts." *Studies in the History of Art* 30 (1991), pages 248-261.

Conroy, Sarah Booth. "A Genesis in Stone." *Horizon* 22 (September 1979), pages 28-38.

Cooper, James F. "Frederick Hart: Inspired by God and Beauty." *American Arts Quarterly* (spring-summer 1990), page 10.

Doubek, Robert W. "The Story of the Vietnam Veterans Memorial." *The Retired Officer* (November 1983), pages 19-20.

Eckhart, Wolf Von. Sculptures for the Cathedral's Portal Arches." *Washington Post.* (8 March 1975).

————. "The Creation." *Washington Post* (23 September 1978).

Feller, Richard. *Completing Washington Cathedral for Thy Great Glory.* Washington, D.C., 1989.

Fleming, Lee. "Blazing Light and Religious Passion." *Washingtonian* 17 (December 1981), pages 63-70.

Giles, Richard. "Sculpting with Light: An American Artist Creates *The Cross of the Millennium.*" *The Silver Cord* 5 (April 1993), page 14.

Hart, Frederick E. "Back to the Future." *American Art Today and Tomorrow.* Hastings-on-Hudson, New York, 1992.

Hess, Elizabeth. "A Tale of Two Memorials." *Art in America* 71 (April 1983), pages 120-127.

————. "More on Viet Memorial Controversy (discussion of April 1983 article, A tale of two memorals)." *Art in America* 71 (November 1983), page 5.

Houtchens, C. J. "A Change of Hart." *Dossier* (Feburary 1988), pages 49-50.

Howett, Catherine M. "The Vietnam Veteran's Memorial: Public Art and Politics." *Landscape* 28 (1985), pages 1-9.

Jordan, Robert. "Washington Cathedral, 'House of Prayer for All.' *National Geographic Magazine* (April 1980), pages 552-573.

Kernan, Michael. "Re-casting the Creation in Just Four Years." *Washington Post* (12 February 1982).

Licht, Fred. *Sculpture: Nineteenth and Twentieth Centuries.* Greenwich, Connecticut, 1977.

Livezey, Emilie T.,"Washington's Magnificent Anachronism," *Christian Science Monitor,* July 18, 1980.

Marling, Karal Ann, and Robert Silberman. "The Statue near the Wall: The Vietnam Veterans Memorial and the Art of Remembering." *Smithsonian Studies in American Art* 1 (spring 1987), pages 4-29.

Meisler, Stanley. "People Thought This Great Church Was Never to Be Finished." *Smithsonian Magazine* (June 1980).

Miller, Richard McDermott. "Co-existence? Modernism and the Figure." *Remove Not the Ancient Landmark: Public Monuments and Moral Values.* In progress.

North, Percy. "Vietnam Memorial, Part II." *New Art Examiner* 7 (April 1985), page 27.

Reynolds, Donald Martin. *The Ideal Sculpture of Hiram Powers.* New York, 1977.

————. *Masters of American Sculpture, the Figurative Tradition, from the American Renaissance to the Millennium.* New York, 1994.

————. "'The Unveiled Soul'—Hiram Powers's Embodiment of the Ideal." *The Art Bulletin* 59 (September 1977), page 394.

Sculpture Group Limited. "The Emerging Flame: A Look at the Work and Philosophy of Sculptor Frederick E. Hart." Northbrook, Illinois, 1989.

Stanley, Alessandra. "Healing Viet Nam's Wounds." *Time* 124 (November 1984).

Sturken, Marita. "The Wall, the Screen, and the Image: The Vietnam Veterans Memorial." 35 (summer 1991), pages 118-142.

Swerdlow, Joel. "To Heal A Nation." *National Geographic Magazine* 167 (May 1985), page 558.

Sullivan, Michael. "Watt Opts for 'Peace with Honor' on the Mall." *Washington Times* (3 February 1983).

141

Teilhard de Chardin, Pierre. *The Phenomenon of Man.* New York, 1959. Introduction by Sir Julian Huxley.
———. *The Divine Milieu.* New York, 1960.
———. *Letters from a Traveler.* Edited and annotated by Claude Aragonnes. New York, 1962.
Wechsler, Jill. "Frederick E. Hart: Sculptures for the Cathedral." *American Artist* 45 December 1981), pages 70-77.
Wilson, Richard Guy. *The American Renaissance.* New York, 1979.
York, Alexandra. "Dedication of Hart and Hand." *American Artist* 54 (September 1990), pages 68-73.

# Index

OF FREDERICK HART'S WORK

*Italic page numbers refer to illustrations*